Barbara Deimling

SANDRO BOTTICELLI

1444/45–1510

TASCHEN

To stay informed about upcoming TASCHEN titles, please request our
magazine at www.taschen.com/magazine or write to TASCHEN America,
6671 Sunset Boulevard, Suite 1508, USA–Los Angeles, CA 90028,
contact-us@taschen.com, Fax: +1-323-463 4442.
We will be happy to send you a free copy of our magazine
which is filled with information about all of our books.

© 2007 TASCHEN GmbH
Hohenzollernring 53, D–50672 Köln
www.taschen.com
Original edition: © 1994 Benedikt Taschen Verlag GmbH
Edited by Rolf Taschen, Cologne
English translation by Michael Claridge, Bamberg
Cover design by Catinka Keul, Angelika Taschen, Cologne

Printed in Singapore
ISBN 978–3–8228–5992–6

Contents

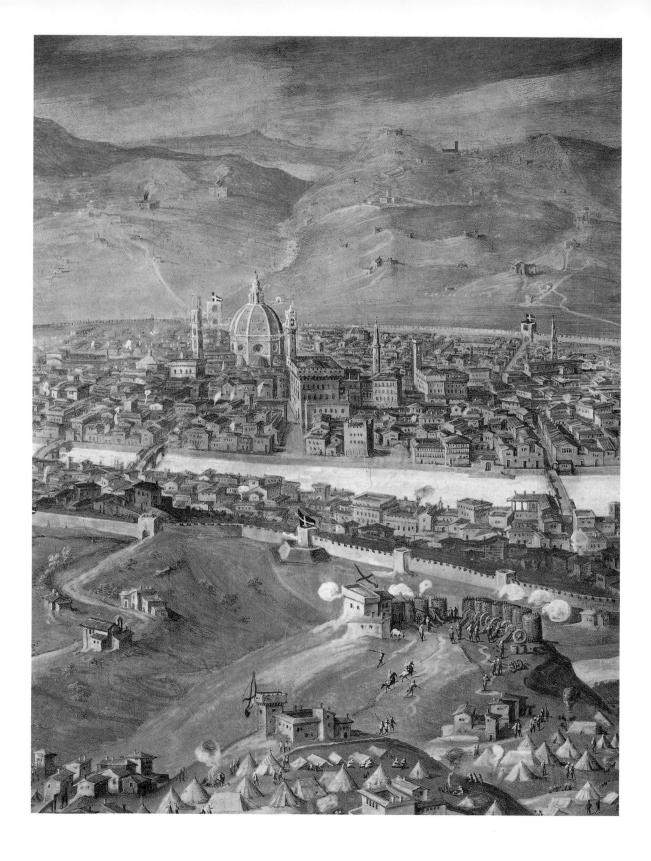

A Master among Fellow-Pupils

Alessandro di Mariano di Vanni Filipepi – so ran the official name of the painter whom we know as Sandro Botticelli. His Christian name, Alessandro, had become shortened in the course of time to Sandro, while "Botticelli" – Little Barrel – was the nickname of his clearly well-upholstered eldest brother, Giovanni. The name became so well-established that it was ultimately conferred upon every member of the family.

Botticelli was born around 1444/45 in Florence, the son of the tanner Mariano di Vanni and his wife, Smeralda. He grew up with his three brothers in the district of the mediaeval Dominican monastery of Santa Maria Novella, not far from the church of Ognissanti, for which he was later to execute one of his most important works. Apart from brief sojourns in other towns, he was to spend his entire life in this region, one which provided him with impressive connections. The Vespucci family lived in the direct neighbourhood, for example; one of their members was Amerigo Vespucci (1454–1512), the famous merchant and explorer, who would later give his Christian name to the American continent. The Vespuccis, loyal friends of the Medicis, the rulers of Florence, were among Botticelli's keenest patrons. Not only did they entrust the artist with the execution of paintings his whole life through; they also recommended him to important figures among those inclined to the commissioning of works of art, not the least of whom were the members of the powerful Medici family.

One of the most important works of the Florentine Early Renaissance was constantly before Botticelli's eyes as he grew up in this district, namely the Trinity fresco by Masaccio in Santa Maria Novella, completed in 1427, in which the laws of central perspective were applied for the first time. The compositional lines, meeting at a common vanishing-point, brought about a new, unified development of the pictorial space, one in which the picture's figures were consistently integrated. The people depicted in the work, who exemplify the newly awoken interest of the time in the representation of the human form, are characterized by a realistically experienced corporeality. In creating the monumental, dignified figures in his picture, Masaccio was turning away from the ideals of the Late Gothic so predominant in painting, in which a delicately executed line and a gently swaying elegance had been to the fore. Instead, he sought his models in the painting of Giotto from a hundred years before, as well as in the art of antiquity, the latter having become the focal point of general interest. Masaccio's work represents the beginnings of Early Renaissance painting in Florence, a movement which would end with those painters who followed him two generations later at the turn of the 15th into the 16th century, namely with Botticelli and his contemporaries on the painting scene.

In his work, Botticelli was to reveal himself equally open to the achievements of the Renaissance as introduced by Masaccio and to the tendencies found in the

Masaccio:
Holy Trinity Fresco, 1427

Giorgio Vasari:
View of Florence (detail), 1558
Although painted almost 50 years after Botticelli's death, Vasari's view of the city gives an impression of the Florence with which the artist would have been familiar. The view is dominated by the cathedral dome, completed by Filippo Brunelleschi, the architect and sculptor, in 1436, nine years before Botticelli's birth.

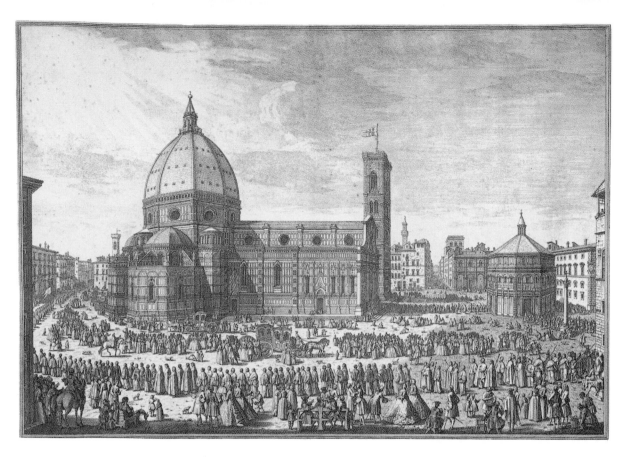

Late Gothic. He adopted the laws of central perspective and studied the sculptures of antiquity, their ideal physique perhaps best manifested in his nude figures. At the same time, the elegance and gracefulness of Botticelli's female forms reveal his affinity to tendencies of the Late Gothic. Yet his paintings also contain a philosophical, political and religious content, far removed from a desire merely to reproduce the charm and beauty of the figures in cheerful scenes from mythology and religion; and it is this which renders his pictures key works for the comprehension of Florentine culture and politics in the second half of the 15th century. Botticelli possessed an extraordinary ability to convey the ideas in the minds of his clients in a vocabulary of form appropriate to the content of the picture, something which made him one of the most sought-after painters of his time.

The philosophical ideas underlying Botticelli's pictures became increasingly displaced by other world-views and the political and religious situation changed, however, causing Botticelli's painting to recede more and more into the background of interest. It experienced another brief upturn in the middle of the 16th century, the age of Mannerism; the artists of that time admired the elegant flow of the lines and the artistic postures in Botticelli's paintings, feeling themselves drawn to the miniature-like delicacy of his vocabulary of form. Thereafter, Botticelli's fame faded at an astoundingly rapid rate. It was not until interest in the Renaissance arose in the 19th century that his paintings were rediscovered, achieving a fame that has continued down to the present. The initial impulse was di-

Filippino Lippi:
The Crucifixion of the Apostle Peter (detail),
c. 1483–85
This detail from Filippino Lippi's frescoes is believed to show Botticelli, aged about 38.

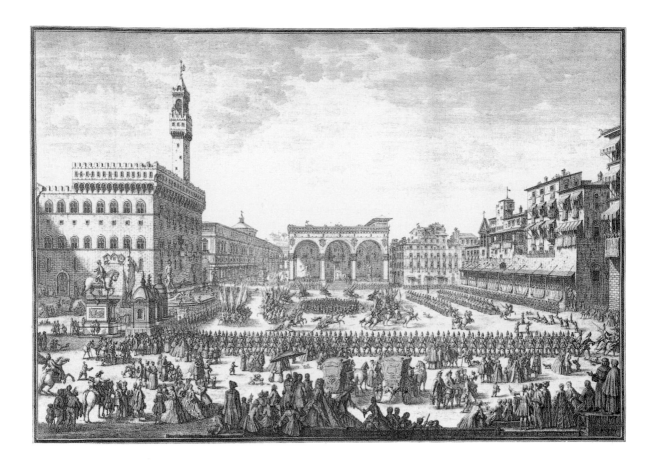

rected towards a philosophical interpretation of the pictures, along with a decoding of his mythological scenes. This was followed by attempts to include the political and religious background, together with the influence exerted by his clients, in analyses of Botticelli's work. This book will essay a brief examination of the various aspects which have played a part in the gradually developing comprehension of Botticelli's art, in order to convey as broad a spectrum as possible of the various elements making up his personality as an artist.

Botticelli began his career as a painter in an indirect way. He initially adopted the art of the goldsmith, a profession regarded as a respected trade in the mid–15th century, as well as being one in which many artists of the Renaissance commenced their training. It is likely that Botticelli was influenced in taking this decision by his second-eldest brother, Antonio, himself active as a goldsmith. In the course of his apprenticeship, Botticelli was to develop a particularly pronounced sense for the decorative fashioning of forms, a feature which can be discerned in all of his paintings.

Upon finishing his training, however, Botticelli changed his plans. Around 1461–62, at the age of about eighteen, he commenced an apprenticeship as a painter with Fra Filippo Lippi – a relatively late start, when one considers that the average apprentice boy of that time was between ten and twelve years old. This change in vocational intentions may have been influenced by Botticelli's close contacts with members of the painting profession, with whom he had come into contact as a goldsmith. Other artists had already taken the step from

Giuseppe Zocchi:
Piazza della Signoria with Festivities to Celebrate the Festival of St John the Baptist, 1744

ILLUSTRATION PAGE 8 TOP:
Giuseppe Zocchi:
The Cathedral and Baptistery with a Procession of the "Corpus Domini", 1744
In the 15th century Florence was the centre of the Early Renaissance. The power exerted by the Medici family through their wealth, together with their patronage in the fields of art, science and philosophy, caused the city to flourish culturally to an extent previously unknown.

9

goldsmith to sculptor or painter at this time, among them Andrea del Verrocchio, who was influenced in changing professions in part by the consideration that goldsmiths tended to receive relatively few commissions. The Carmelite monk Lippi, under whom Botticelli served his apprenticeship, was one of the most famous painters in mid-century Florence. The greatest families of the town, among them the Medicis, commissioned paintings and fresco decorations from him for their palaces and private chapels. Lippi's art is distinguished by its combination of the delicate Gothic vocabulary of form with the achievements of the Renaissance, the latter seen in the recently discovered corporeality of the figures and the in-depth composition of the pictorial space through the employment of central perspective; all this was to have a decisive influence upon Botticelli. Since 1452 Lippi had been living almost exclusively in Prato, a town about twenty kilometres distance from Florence. Here he painted the frescoes for the chapel of the Cathedral's main chancel with scenes from the lives of St Stephen and St John the Baptist; they are considered to be among his greatest

Adoration of the Magi (detail, cf. p. 11)
Botticelli portrays the retinue of the Magi in splendid and luxurious garments. Thus must the parades of the Florentine Brotherhood of the Magi have appeared, who imitated the processions of the Biblical Magi in Botticelli's day, with members of the most important families participating in pompous attire.

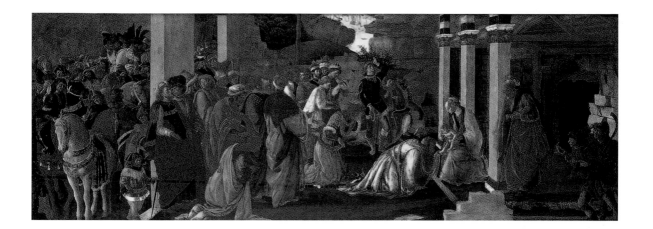

Adoration of the Magi, c. 1465–67
This painting is one of the first original works by Botticelli, done during the last years of his five-year apprenticeship under Fra Filippo Lippi. A certain compositional weakness is still visible in the arrangement and positioning of the numerous figures.

works. Upon completing the main chancel chapel in Prato, Lippi followed a call to Spoleto, where he and his most talented assistants similarly decorated the chapel of the Cathedral's main chancel with frescoes from 1467 onwards.

It follows from this that Botticelli trained under Lippi in Prato for a period of some five years, from 1461/62 to 1467. As with every other apprentice, his initial studies were devoted to the composition, production and preparation of paints. The stones had to be ground and then mixed with the correct quantity of binder; at the same time, he was taught the various techniques of painting frescoes and panels. He next had to prepare himself for painting itself by means of drawings; not until then was he permitted to execute his first independent paintings, albeit work of secondary importance, such as the depiction of the sky, the decoration of garments, or the application of gold leaf. Finally, he was allowed to participate in the painting of background landscapes and secondary figures.

One of the earliest independent works by Botticelli is the *Adoration of the Magi* (Illus. pp. 10, 11), painted by the young artist around 1465–67, thus some three to five years after commencing his training in Lippi's workshop. In light of the picture's elongated form, it seems reasonable to assume that it was used to decorate a piece of furniture, and could thus have functioned as the raised back-rest of a sofa or bed, following the custom of the time. The painting reveals the young artist to have been still very unsure of himself, something seen particularly clearly in the composition of the crowded scene, the latter simultaneously illustrating Botticelli's closeness to Lippi. The pupil had learnt how to portray spatiality from his master: the illusion of depth is reinforced by the small wall in the foreground on the right, which serves to move the event of the Adoration deeper into the pictorial space. The clear division of the painting into three sections, achieved by means of the ruinous wall on the left and the pillars on the right-hand side, also points to Lippi's influence. However, Botticelli clearly had difficulty in bringing the individual spaces to life in a harmonious manner, and in linking them with one another. The left-hand side appears packed with people and animals, almost overcrowded; the half-empty right-hand side is incapable of offering any counterbalance to it. Furthermore, the shepherds hurrying from the right towards the events portrayed in the picture find no echo in the depiction of the horses on the opposite side, the latter merely stand there, motionless, gazing out of the painting. It is only with difficulty that the dwarf standing on the opening in the masonry between the left-hand and central sections of the picture (Illus. p. 10) manages to link them. The

uncertainty of the still inexperienced Botticelli may also be seen in the artificiality of the animation which the artist attempts to inject into the portrayal. The depicted figures are turning to face one another, yet their gazes do not meet, causing them to stand in isolation beside one another. Some of them are looking and pointing at things happening outside of the picture and which have no significance for the observer, since they bear no direct relationship to the events portrayed in the work. This is the case, for example, with the man gazing upwards in the entourage on the far left, with the man wearing a crown who is standing in the opening in the wall on the left of the background, and with the young man in the centre, directly behind the Magi.

Despite these weaknesses, which may be ascribed to the uncertainty of an artist at the beginning of his career, the picture also reveals elements in which the characteristic features of Botticelli's art may already be distinguished. These can be detected in the varied treatment of the subject, for instance, and also in the emphasis on the beautifully curved lines and graceful posture of the figures, something particularly evident in the depiction of the Virgin.

This painting is the first in a long tradition of Adoration pictures by Botticelli; a total of five works by him dealing with this subject have come down to us. The frequency with which this scene was painted, not only in Botticelli's œuvre but generally in 15th-century Florence, should be seen in connection with Florentine life and with the existence of Brotherhoods at that time such as the so-called "Brotherhood of the Magi", the Compagnia dei Magi, considered one of the most important congregations in Florence. Such Brotherhoods had been significant institutions in Florentine life since the Middle Ages. They took the form of congregations of lay persons who performed services for the poor and the sick, in accordance with Christian teaching. Over and above this, the Compagnia dei Magi also staged a grandiose procession through Florence every five years on Epiphany, the feast day of the Magi, one that took the procession of the Biblical Magi as its inspiration. We know from contemporary descriptions that these processions were absolutely magnificent, the participants dressing in exotic robes adorned with jewels and wearing splendid hats, the parade accompanied by hundreds of horses. The magnificence and pomp of these processions are reflected in contemporary paintings of the Adoration of the Magi, as in those by Botticelli.

In addition to the *Adoration of the Magi*, some depictions of the Virgin from Botticelli's earliest phase have also survived. They reveal especially vividly Botticelli's close artistic relationship to his teacher, Filippo Lippi. For example, the composition of his paintings *The Virgin and Child with an Angel* in Florence (Illus. p. 13, top left) and in Ajaccio in France (Illus. p. 13, bottom left) is modelled on a picture of the Virgin by Filippo Lippi (Illus. p. 13, bottom right), in which the angel, gazing at the observer, is holding the Christ Child up to Mary, who is depicted in three-quarter profile. For his part, Botticelli extended the composition in the Ajaccio painting to a full-figure representation, while he replaced Lippi's landscape view when doing the Florentine work with an arch supported by two columns. However, his closeness to Lippi is not restricted to the adoption of the latter's compositions alone. It may also be seen equally in the gently swaying contours outlining the forms, as well as in the decorative treatment of the garments with their richly imaginative drapery – compare, for example, the serpentine-like course taken by the collar of Mary's cloak in the painting *The Virgin and Child with Two Angels and the Young St John the Baptist* (Illus. p. 13, top right). Even the transparent veil falling from Mary's head and presenting a vivid contrast to the dark colours of her dress and cloak is reminiscent of Filippo Lippi, Botticelli's teacher.

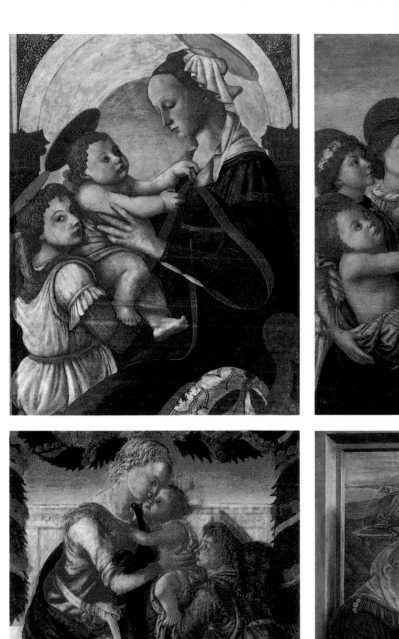

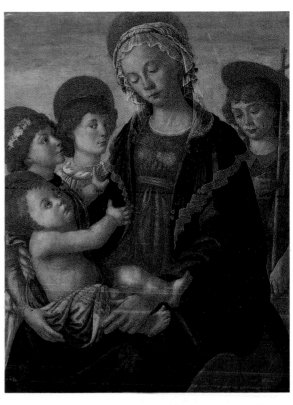

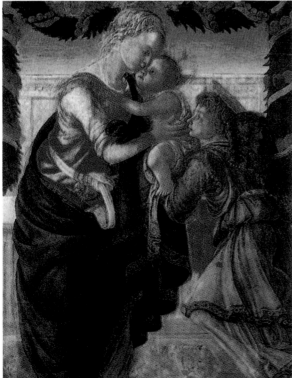

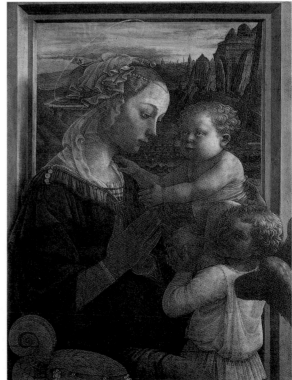

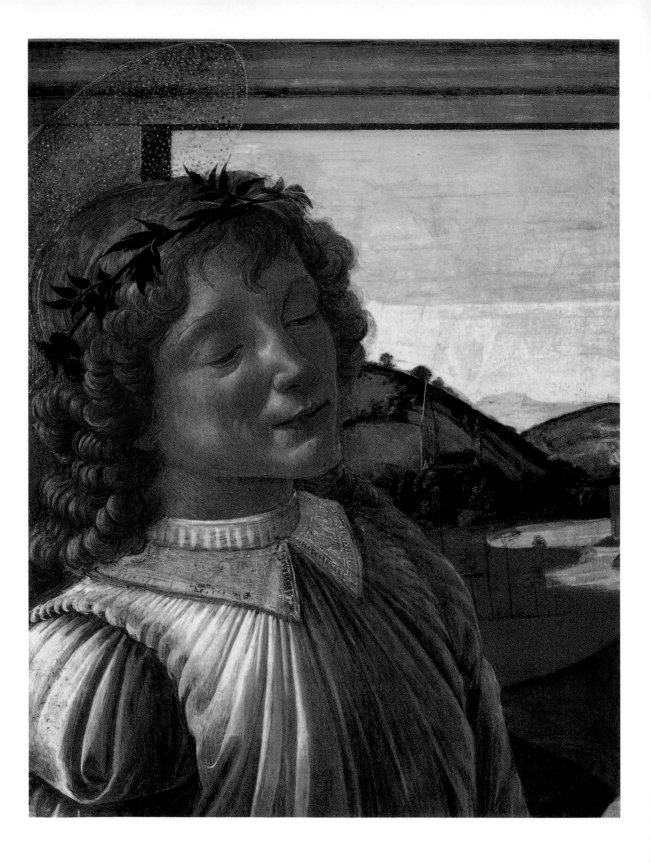

Biblical Stories and Initial Portraits

After concluding his training under Lippi in Prato sometime around 1467, Botticelli went to Florence, where he set up a workshop of his own by 1470 at the latest. In severing his direct links with his teacher and settling down in Florence, the young artist rendered himself receptive to new influences, which is clearly manifested in his turning ever more to a powerful vocabulary of form. In doing this, Botticelli was following the Pollaiuolo brothers, Piero and Antonio, who lived in Florence, and also Andrea del Verrocchio, the teacher of Leonardo da Vinci. These men were particularly responsible for the introduction of sculptural values into Florentine painting, which had previously been dominated by elements of Gothic art, giving less prominence to plastic qualities.

Botticelli's change in style is especially visible through an examination of two panels depicting the Virgin, dating from shortly before and sometime around 1470 respectively and lending themselves to comparison on grounds of the similarity of their composition (Illus, p. 16). This reveals Botticelli's new orientation, one in favour of more voluminous forms demonstrating a more elaborate three-dimensional treatment. Look, for example at the Virgin's face: in the earlier example it appears mellow and flat, whereas the later version is distinguished by a more powerful, naturalistic modelling in which the interplay of light and shade serves to articulate the anatomical structures. The greater emphasis on corporeality corresponds to the clearer utilization of the pictorial space. A golden background with a glory of Cherubim spreads out behind the Virgin in the earlier painting, emphasizing the expanse. In the later work, in contrast, the spatial situation appears more tangible, with the Virgin sitting under an arch supported by four columns, a garden with roses stretching away behind them – to be understood as symbolizing the Virgin's purity.

A similar change in style on Botticelli's part may be perceived in the small panels *The Return of Judith to Bethulia* and *The Discovery of the Dead Holofernes* (Illus. p. 17, top and bottom), both from shortly before 1470. The small scale of the paintings, a mere 31 x 24 cm in size, indicates that they were not intended as decoration for a piece of furniture. We know from contemporary inventories that paintings of similarly small dimensions were kept as precious objects in caskets or leather cases, to be admired at close proximity or shown to friends on special occasions. The miniature-like delicacy and detailed execution, conceived for close-range observation, leads to the supposition that the little panels were intended for just such a purpose.

The Biblical tale of Judith, who slew Holofernes, the Assyrian king's commander-in-chief, because he represented a deadly threat for the Hebrews in Bethulia, was one of the favourite subjects of the Florentine Renaissance. Judith was considered the prototype of female strength, since she alone had summoned

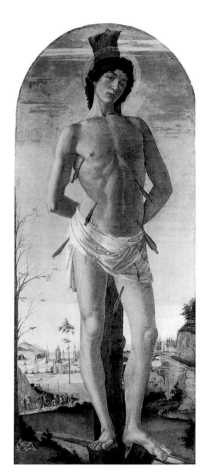

St Sebastian, 1473
St Sebastian had been one of the most revered saints in Italy since the Middle Ages as patron saint of those afflicted with the plague. This picture was probably an ex-voto, commissioned in gratitude for preservation from the plague.

The Virgin and Child with an Angel (detail, cf. p. 21)

15

up the courage to murder the tyrant. In *The Return of Judith to Bethulia*, Botticelli shows us Judith together with Abra, her maid, the two of them striding out in a well-nigh furious manner. Abra is carrying Holofernes' severed head on her own head, while Judith has an olive branch in her hand as a symbol of peace, which she is bringing to the Hebrews. Botticelli has succeeded here in capturing both movement and stillness in a unique balance. Judith is pausing a moment in her striding forward to turn towards the observer, self-assured if not without a touch of melancholy, exactly as if she wished to present herself as the victor. We will come to see that this interaction of striding forward and tableau, of motion and stillness, constitutes a characteristic of Botticelli's work, one that may be found in his later output as well.

Botticelli has captured the discovery of Holofernes in a dramatic manner. The half-naked body of the dead man is placed in such a way that the observer would appear to be standing on the opposite side of the tent and gazing down upon the headless trunk, rendering him an accomplice to the discovery of the murder. This dramatization of the event led Botticelli to pay less attention to the accuracy of his composition's perspective. Although the position of the Assyrians standing around the bed is excessively high, its effect is to make the body of the dead Holofernes the central focus of interest. The well-built, youthful figure betrays Botticelli's study of and orientation towards the classical ideal of beauty. This results in a contradiction, however, since the severed head borne by the maid has the features of an elderly, grey-haired man, one which can be associated only with difficulty with the youthful body.

The imbalance of perspective seen in *The Discovery of the Dead Holofernes* suggests a dating of these two small panels to some point in time before *Fortitudo* (Illus. p. 18, right), the personification of Fortitude, from 1470, a work making manifest Botticelli's final breakthrough to a vocabulary of form all his own. We are concerned here with the artist's first datable picture, its origin precisely documented. The painting belongs to a cycle of the seven cardinal Virtues – Faith, Hope, Love, Fortitude, Justice, Prudence and Temperance – intended as the back-rests of chairs. The cycle was commissioned by the Sei della Mercanzia, a tribunal of six judges whose task it was to pass judgement on disputes between merchants, which explains their choice of subject. The Virtues served as incentive and admonition to both the judges and the judged. The commission for the paintings was awarded in 1469 to Piero del Pollaiuolo; however, he failed to complete them all by the arranged date, with the result that the task of depicting two of the Virtues was transferred to Botticelli. It is possible that the selection of this artist – who, after all, was still relatively unknown – was influenced by the mediation of his neighbour, Giorgio Antonio Vespucci, who had good contacts with one of the tribunal's members. For reasons unknown to us, however, Botticelli painted only the personification of Fortitude, for which he received his payment on 18th August, 1470.

A comparison with one of Pollaiuolo's Virtues, namely *Temperantia* (Temperance, Illus. p. 18, left), readily demonstrates that Botticelli knew how to deal with his allotted topic in a more convincing manner than his rival. Both painters were required to adhere to the same guidelines with respect to the form and dimensions of their paintings, as well as their general composition, in order that the unity of the cycle be maintained. For his part, however, Pollaiuolo followed the laws of the recently discovered central perspective extremely meticulously, placing his figure some way back in the pictorial space – note where her feet have been placed – in precisely such a way as if she were being sucked into the background by the lines of perspective. In contrast, Botticelli has positioned *Fortitudo* so close to the picture's edge that the toes of her left foot even protrude beyond the step to her throne, infringing upon the sphere of the observer. In this manner, Botticelli's figure escapes being dominated by the throne's architecture and the perspective construction, instead maintaining a direct presence that casts its spell over the observer. The robes of *Fortitudo* have been depicted with such elegance, diversity and splendour that the gown worn by *Temperantia* strikes one as somewhat unimaginative in comparison. Botticelli's training as a goldsmith is noticeable in the decorative ornamentation of the breastplate worn by *Fortitudo*. Botticelli has inserted decorative acanthus-like forms at the sides and along the upper end of the throne's semicircular border, in order that it should accord with the pointed arch form of the frame; Pollaiuolo has left these spaces unconnected. With the exception of the military staff of office held loosely in her hands, *Fortitudo* is bereft of any attributes. Botticelli has nonetheless characterized her in a sublime manner in portraying the nature of fortitude. Through her bearing and posture, *Fortitudo* radiates a calm strength and a self-assurance such as is characteristic of this Virtue alone.

Two further pictures should be seen here in direct temporal proximity to *Fortitudo*, namely the *Adoration of the Magi* (Illus. p. 19) and the *Virgin of the Eucharist* (Illus. p. 21). The name given the portrait of the Virgin refers to the ears of corn and the grapes which the angel is holding out towards the Christ Child, who is blessing the offerings. They serve as reminders of Christ's Passion, the sacrifice of His flesh and blood, as recalled in the celebration of the Eucharist, the transubstantiation of the bread and wine. The closeness of the picture of the

TOP:
The Return of Judith to Bethulia, c. 1469/70

BOTTOM:
The Discovery of the Dead Holofernes, c. 1469/70

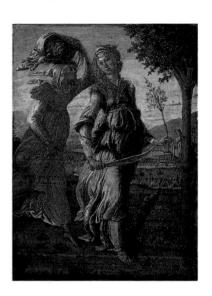

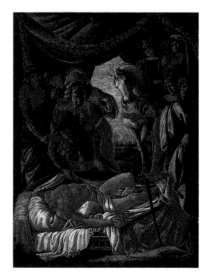

The miniature-like delicacy and detailed form of the two small panels leads to the assumption that they were kept as precious objects in valuable caskets or leather cases, to be taken out and admired only on special occasions.

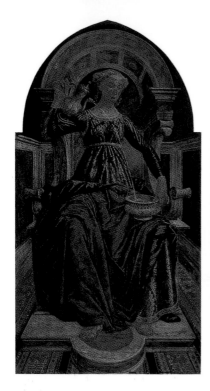
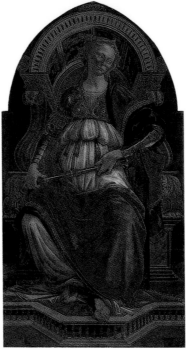

Virgin to *Fortitudo* may be perceived especially clearly in the lively interplay of light and shade seen in the flesh colours, which accentuate the bone structure of the bodies – look, for example, at the hands of *Fortitudo*, so typical of Botticelli's art, or at the faces of Mary and the angel.

The *Adoration of the Magi* demonstrates Botticelli's continued progression in his handling of this subject. The main event is no longer located to one side, as was the case in the earlier painting (Illus. p. 11), but has been moved into the centre of the picture. In portraying such a detailed wealth of variation, Botticelli was following Leon Battista Alberti, the artist and scholar, who had recommended in his treatise on painting that a picture be so executed as to embrace the greatest possible diversity, for the edification of the observer. Botticelli thus not only painted his figures clothed in highly imaginative robes such as present a wealth of variation, but also captured them in the most varied of postures, gestures and facial expressions. The relationship between the various figures here, and between these figures and the action that is taking place, also appears tighter than in the earlier *Adoration*; nevertheless, they still do not yet constitute a dramatic unity.

Three years after *Fortitudo*, Botticelli painted his *St Sebastian* (Illus. p. 15), which was put up with great ceremony in 1474 on one of the pillars in Florence's Santa Maria Maggiore church on 20th January, the feast day of the saint. The picture's location explains its unusually long format. It had been common custom since mediaeval times to affix paintings to the pillars of church interiors. In the course of time, however, these pictures were removed from their original locations, so that the interior view of churches as they appear today, with their unadorned pillars, in fact presents an inaccurate picture.

Legend has it that the Roman emperor Diocletian had archers fire arrows at

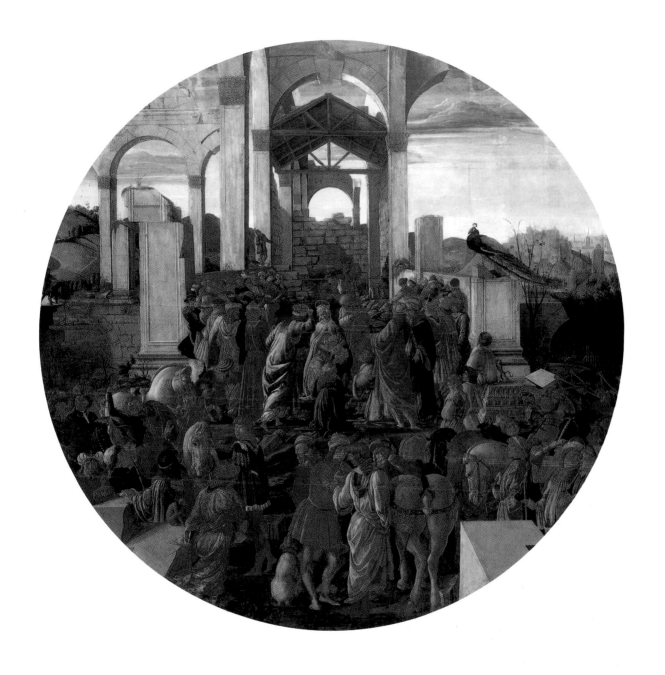

Adoration of the Magi, c. 1470–75
In his treatise "Della Pittura" (1435), the
Florentine humanist Leon Battista Alberti re-
commended the depiction of the "wealth and
diversity of things", such as "old people,
young people, boys, women, girls, children,
chickens, puppies, little birds, horses, sheep,
buildings, tracts of land, and all such
things…" Botticelli took Alberti's advice, as
can be seen from this picture.

St Sebastian on account of the latter's Christian belief, an ordeal which the saint survived, however. Since the Middle Ages, the arrows of his ordeal had been equated with the arrows of the plague which God hailed upon the earth in punishment of mankind. The consequence of this image was that St Sebastian became one of the most revered patron saints of those afflicted with the plague. 15th-century Florence was regularly afflicted with bouts of the plague, causing many altars and chapels to be erected in honour of St Sebastian and decorated with his portrait. Such endowments were made in order that prayers be offered up for deliverance from the plague, or else in gratitude for past preservation from it; Botticelli's picture would presumably have served such a purpose.

If we leave the portrayal of the dead Holofernes out of consideration, then *St Sebastian* may be regarded as Botticelli's first male nude. The artist is following classical ideas in his harmonious proportions and balanced "contrapposto". However, a sense of uncertainty is revealed in the foreshortening of the saint's feet, confirming this picture as belonging to Botticelli's early phase.

Somewhere around 1475, Botticelli painted the famous *Adoration of the Magi* for Guasparre del Lama (Illus. p. 22), a work in which the artist also depicted himself (Illus. p. 23). This painting established Botticelli's fame in Florence, and may rightfully be considered the high point of his early artistic output. Guasparre del Lama was a parvenu from the humblest background with a dubious past – he had been convicted of the embezzlement of public funds in 1447. He had been working since the 1450s as a broker and money-changer, something which brought him considerable wealth. In order that he might also obtain the high social standing which he lacked, he enrolled in the most prestigious brotherhoods and endowed a chapel in Santa Maria Novella, which he decorated with Botticelli's altar-piece. Del Lama's career did not last long, for he soon slipped back into his dishonest business practices. In January, 1476, he

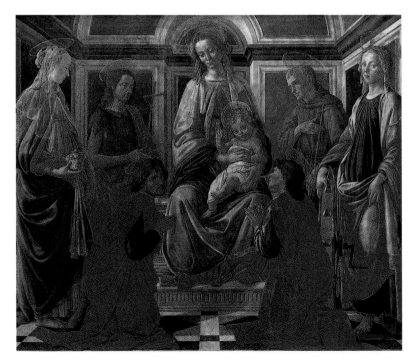

The Virgin and Child with Six Saints, c. 1470
Botticelli's first altarpiece depicts Cosmas and Damian, the patron saints of doctors, kneeling in the foreground; John the Baptist, patron saint of the city of Florence, and Mary Magdalene, standing to the right of the Virgin; and Francis of Assisi and St Catherine of Alexandria on her left.

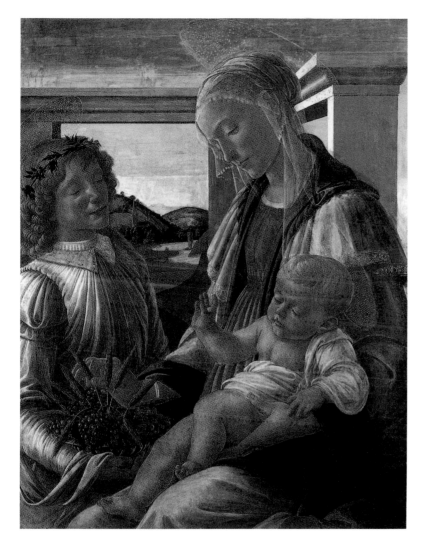

was convicted of fraud by the judges of the Guild of Money-Changers, leading to his being banned from conducting any further professional activity in this area, together with the loss of his so laboriously established standing in society. He returned to his earlier life of mediocrity, to die in humble circumstances.

All that remained of del Lama's brief social advancement was Botticelli's *Adoration of the Magi*, intended for his chapel in Santa Maria Novella. Contemporary accounts record that the painting had a costly marble frame and was located on an altar erected against the inner wall of the church's façade and surrounded by a wrought-iron balustrade.

Del Lama's Christian name, Guasparre (Caspar), determined the subject-matter of the picture, since the first of the Magi was his patron saint. Del Lama was thus following a practice which had come down from mediaeval times, namely the commissioning of altar paintings depicting one's patron saint as a means of assuring oneself of the saint's special intercession on one's behalf at the Last Judgement. Del Lama may be seen among the crowd of people on the right-

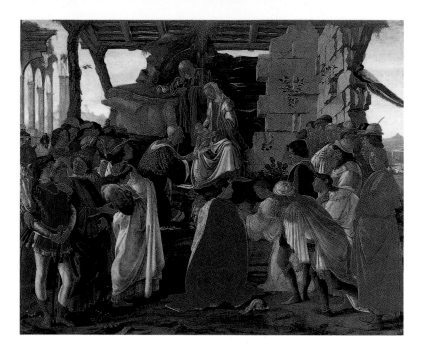

hand side of the picture, an elderly man with white hair and a light blue robe looking at the observer and pointing in the latter's direction with his right hand. The most famous members of the Medici family are portrayed together with del Lama; controversy rages as to their precise identification, although there is no doubt that the eldest king, kneeling before the Virgin and the Christ Child, is a representation of Cosimo the Elder, founder in the 1430s of what would be dynastic rule by the Medici family over Florence for many years to come. The question naturally arises as to what Guasparre del Lama hoped to achieve by depicting the Medici family in his altar painting. It would appear that the parvenu wished to express in this manner his attachment to the powerful Medici, who were also enrolled in the Arte di Cambio – the Guild of Money-Changers – and upon whose goodwill he was dependent for the successful outcome of his business.

A comparison of Botticelli's painting with his earlier representations of the Adoration (Illus. pp. 11, 19) reveals the extent to which the artist had further developed and compensated for his earlier weaknesses. The ground rises gently, so that the faces of almost everyone present can be seen, as can the great variety of postures and gestures that these figures embody. However, Botticelli has combined those involved in an ever more compelling fashion to create a dramatic unity, one concentrated wholly upon the main event. Furthermore, he has moved the central king slightly away from the main axis, enabling the observer's gaze to fall unimpeded upon the Virgin, who is now no longer in danger of becoming lost in the throng, as was still the case in the London portrayal (Illus. p. 19).

Botticelli was also establishing a reputation as a portraitist at this time, as is evidenced by several pictures from the 1470s. Particular attention is drawn to the *Portrait of a Man* holding up towards the observer a medallion bearing the likeness of Cosimo Medici the Elder (Illus. p. 25). The identity of the portrait's subject has given rise to considerable conjecture. Some believe him to be a

ILLUSTRATION TOP AND DETAIL PAGE 23:
The Adoration of the Magi (The Del Lama Adoration), c. 1475
This picture was commissioned by Guasparre del Lama, a social upstart. Del Lama had Botticelli paint portraits of members of the Medici family as the Magi and some of their entourage in order to give expression to his attachment to this powerful family. Among the company of worshippers, we recognize Botticelli on the right-hand side of the picture, who has depicted himself gazing at the observer, as was customary in self-portraits at that time.

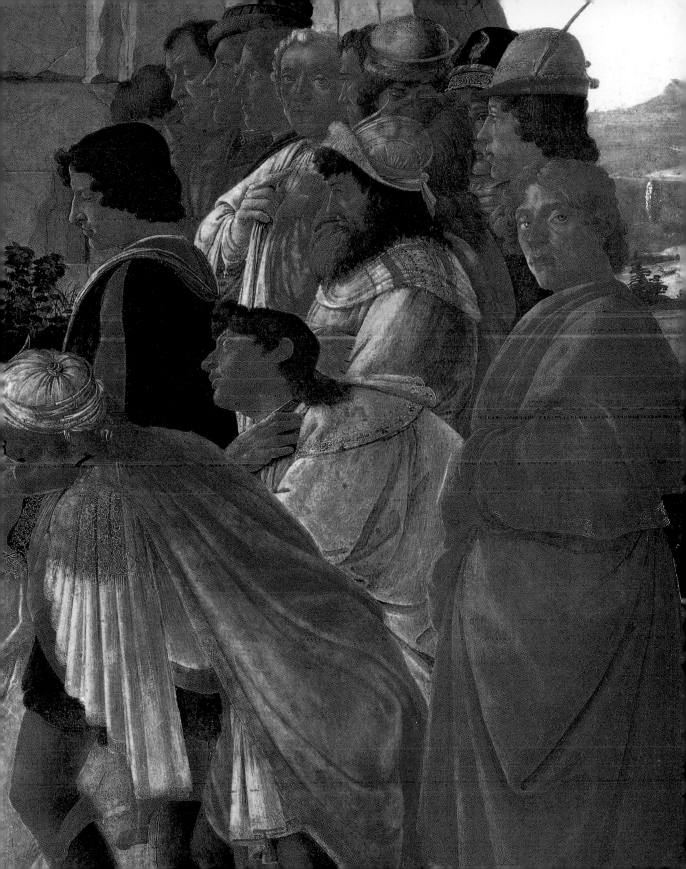

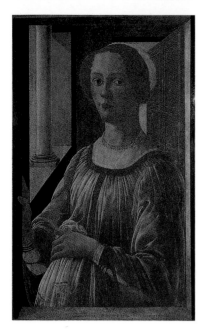

Portrait of a Lady (Smeralda Brandini?),
c. 1470–75

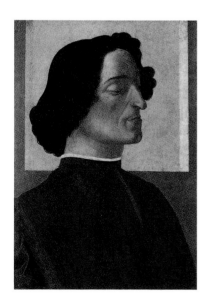

Portrait of Giuliano de' Medici, c. 1476–78

ILLUSTRATION PAGE 25:
**Portrait of a Man Holding a Medallion of
Cosimo de' Medici**, 1475
Various portraits dating from the 1470s on-
wards attest to the fact that Botticelli was also
sought after at this time as a portraitist. The
subjects are primarily high-ranking, well-
known personalities from Florence.

loyal follower of the Medici; others a relation of the family; one of Cosimo's
godsons; or even the selfsame man who produced the Cosimo medallion. In con-
trast to Botticelli's late portraits, his earlier likenesses are distinguished by the
compositional detail of their backgrounds, something also visible in this paint-
ing. A broad landscape opens up behind the subject of the portrait, traversed by
a river in which the golden light of the sun is reflected. Here, too, as has already
been seen in *The Virgin of the Eucharist* and *Fortitudo*, the vivid modelling in
the interplay of light and shade serves to underline the anatomical structures of
face and hands, a feature typical of Botticelli's early output, yet one that would
give way in the course of time to a less sharply pronounced, gentler modelling.

This play of light and shade is also characteristic of a further portrait by Botti-
celli in which a young woman is depicted in an inner room (Illus. p. 24, top). Il-
luminated by bright light, the figure presents a contrast to the dark walls of the
small chamber. She would appear to have just opened the window in order to
show herself to the observer, whom she has fixed with her gaze. This gives the
portrait's subject a vivid immediacy. She is holding a handkerchief in her hand,
something understood in the 15th century as symbolizing high social standing.
And the young woman indeed came from an old-established and much re-
spected Florentine family, if we are to believe the inscription appended in the
16th century, according to which the portrait's subject is Smeralda Brandini.

One of Botticelli's most famous portraits is that of *Giuliano de' Medici* (Illus.
p. 24, bottom), the younger brother of Lorenzo the Magnificent, ruler of
Florence at that time. To this day, it has proven impossible to unravel the pic-
ture's meaning. Giuliano had been murdered on 26th April, 1478, during Mass
in Florence Cathedral, the victim of a conspiracy by the Pazzi family against the
Medici. His brother, Lorenzo, had only just managed to take refuge in the
vestry. Giuliano's eyes are lowered in Botticelli's portrait, an unusual feature in
such a work. Should this be understood as a reference to his death? If so, then
the painting may be regarded as commissioned in memory of the murdered
man. However, in another version of this portrait a turtle-dove sits on a dry
branch in the foreground. This suggests an alternative interpretation: a belief of
classical origin prevailed in those days to the effect that a turtle-dove would no
longer mate after the death of its partner, but would only seek out dry, leafless
branches from then on, caught up in eternal mourning. The turtle-dove could be
understood in this sense to symbolize Giuliano's eternal mourning for Simonetta
Vespucci, his "knightly love", who had died in 1476 at the age of eighteen. One
year before, during a knightly tournament organized in his honour by his parents
and modelled upon mediaeval tournaments, Giuliano had chosen Simonetta Ves-
pucci as his beloved. This meant that he – as in the age of chivalry – wor-
shipped her with an unattainable pure love destined never to be fulfilled. In re-
ality, his adored Simonetta was married to a member of the Vespucci family.
Botticelli had painted a standard for Giuliano on the occasion of this tourna-
ment, depicting in allegorical form Giuliano's unfulfilled love for Simonetta. It
is possible, therefore, that Giuliano himself could have commissioned the por-
trait in her memory.

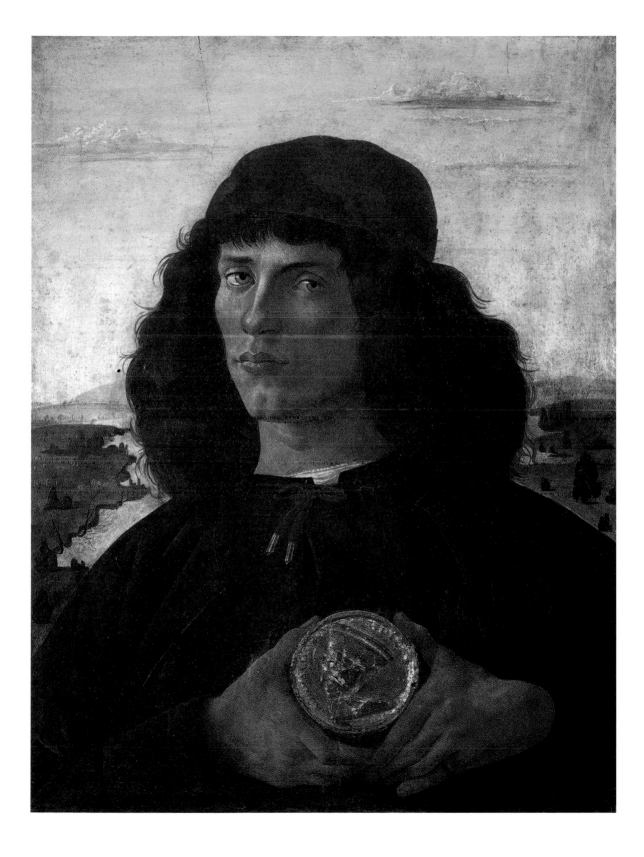

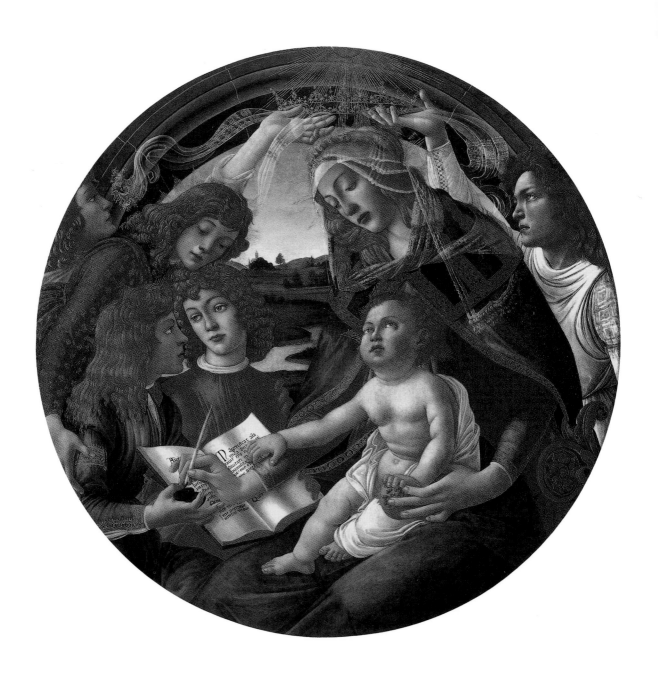

Artistic Self-Discovery

Botticelli created his *Madonna del Magnificat* (Illus. p. 26) in the early 1480s. At the time, it was in all likelihood his most famous picture of the Virgin, something indicated by the five contemporary replicas which we have of the painting. Botticelli has portrayed the Virgin writing, engaged in completing the final lines of a book held out towards her by two angels. She is moving her quill towards the inkpot with a graceful movement of her hand, in order to finish the text which is being dictated to her by the Christ Child. It has been possible to identify the lines on the left-hand side of the book as the hymn of St Zacharias, a song on the birth of his son, John the Baptist, principal patron saint of Florence. It would thus appear probable that Botticelli had executed the painting for a Florentine client. On the right-hand side of the book are the first words of the Magnificat, Mary's hymn of praise, which gave the picture its name. Together with the rather earlier London *Adoration of the Magi* (Illus. p. 19), this picture is one of Botticelli's first round pictures, or tondi. Such tondi were very popular in 15th- and 16th-century Florence. However, they served not as altarpieces but as decoration in the rooms of secular buildings, such as private palaces or guild houses. Botticelli has integrated his large figures into the circular format of the painting in a particularly sensitive manner. The slightly bowed posture of Mary's body and her left arm form a semicircle that follows the curve of the frame. This matching of the composition to the pictorial form is repeated on the opposite side in the bent right arm of the angel who is leaning over the two angels in front in order to cast a glance at the book lying open before them. It is evident, however, that Botticelli had some difficulty accommodating the fourth angel on the left-hand side, who is in the process of placing the heavenly crown upon Mary's head; indeed, it seems almost as if the other three angels are squeezing him out of the painting.

This portrait of the Virgin represents the costliest tondo that Botticelli ever created: in no other painting did he employ so much gold as in this one, using it for the ornamentation of the robes, for the divine rays, and for Mary's crown, and even utilizing it to heighten the hair colour of Mary and the angels. As the most expensive paint, gold was normally used only sparingly. Its liberal employment here will therefore have been at the express wish of the person commissioning the work.

The background of the picture opens out into a landscape, in similar manner to the background in the *Madonna del Libro* of almost identical date (Illus. p. 27), where the open window allows the observer a glimpse of the view outside. These landscapes point to the influence exerted upon Botticelli by contemporary Netherlands' artists such as Jan van Eyck, Rogier van der Weyden and Hubert van der Goes. Trading relations between Italy and the Netherlands had been growing more intensive since the 15th century, resulting in many Floren-

The Virgin Teaching the Child to Read (The Madonna del Libro), c. 1480/81
Those lines of text that may be deciphered would indicate that the book is the "Horae Beatae Mariae", Mary's Book of Hours.

The Virgin and Child with Five Angels (The Madonna del Magnificat), 1480/81
Circular paintings, or tondi, were very common in the 15th century and served to furnish private palaces or guild houses. This is the most costly circular painting that Botticelli ever created; in no other tondo did he employ so much gold. In those days, gold represented the most expensive paint; the quantity used in a picture was at the discretion of the person commissioning the work.

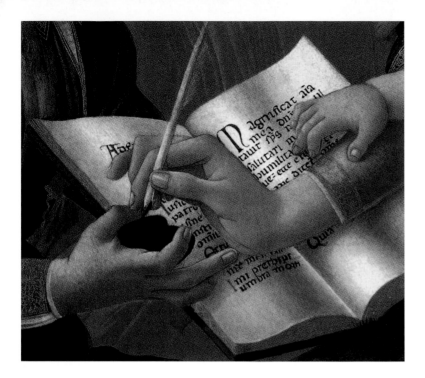

tine merchants and bankers travelling northwards. Among the mementos which these people brought back were paintings revealing other artistic conceptions and ideals. The Italian painters particularly admired the detailed execution of individual pictorial motifs, the realistic fashioning of the figures in the pictures, and the atmospheric effect of the landscapes as rendered in the art of their colleagues north of the Alps, and each incorporated the motifs of the latter into his own pictures after his own manner.

The superiority with which Botticelli dealt with the subject of a picture was becoming ever more apparent, and may be seen especially vividly in his earliest surviving fresco, depicting *St Augustine* (Illus. p.31, top right). Botticelli painted it in 1480 for the Vespucci family, whose coat of arms is affixed to the moulding above the figure of the saint. The painting was conceived as a counterpart to the fresco of *St Jerome* executed at the same time by Domenico Ghirlandaio (Illus. p.31, top left). Both works were originally to be seen in Ognissanti, the church of the Humiliati, in direct proximity to Botticelli's workshop. They were originally placed on either side of the entrance to the monks' choir; Ghirlandaio's fresco was on the left and Botticelli's on the right, so that the two saints were facing each other. The two pictures should indeed be considered as constituting a narrative whole, the resolution of which lies in Botticelli's depiction of St Augustine. On the right-hand side of the picture, under the figure of the saint, a clock may be seen (cf. Illus. p.31, bottom), the hand of which is standing between I and XXIV, XXIV heralding the hour of sunset. The fact that St Augustine is portrayed as sitting in his cell at a very precise time of day, namely shortly before sunset, reveals not only that we are confronted here with a representative depiction of the saint but also that allusion is being made to a particular incident. The key to understanding the picture is contained in the indication of the time of day: St Augustine records, in one of the epistles ascribed to

ILLUSTRATIONS TOP AND PAGE 29:
The Virgin and Child with Five Angels
(details, cf. p.26)
The Virgin is moving her quill towards the inkpot with a graceful movement of her hand, so as to write in the book lying open before her the final words of the Magnificat, the song of praise from the mother of God, as dictated to her by the Christ Child.

28

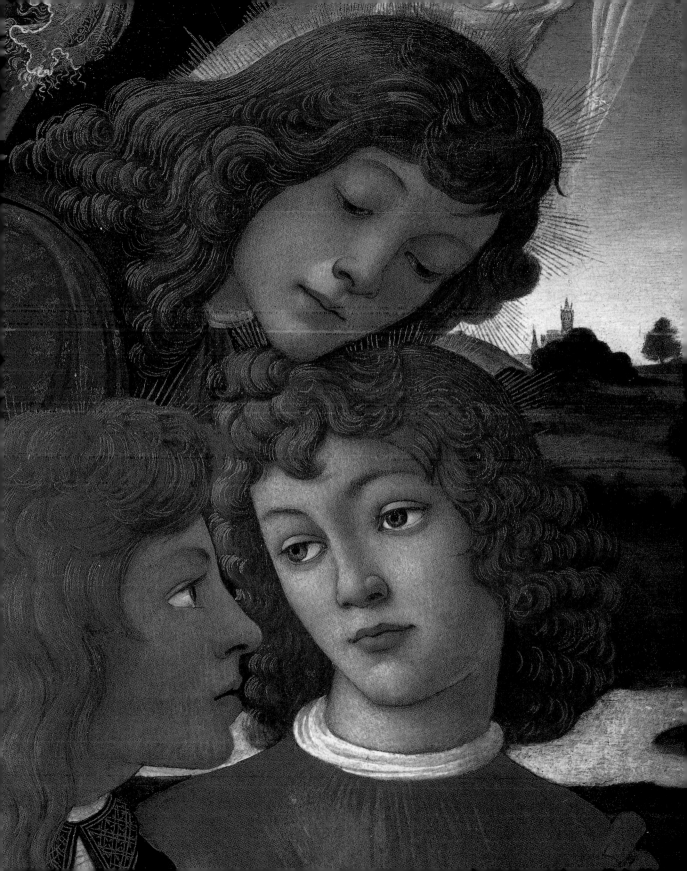

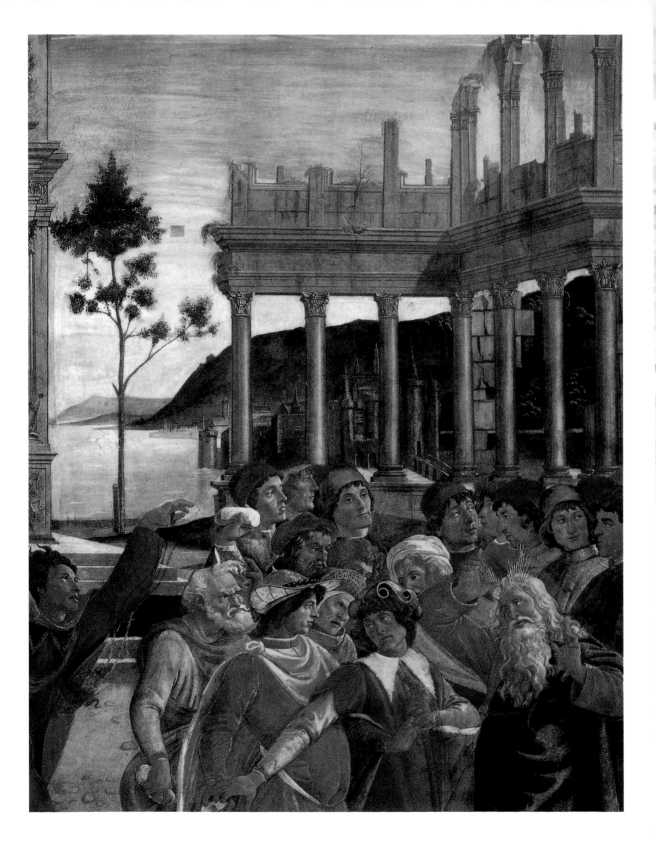

A Commission from On High

The rapid spread of Botticelli's fame was not restricted to Florence. The artist had been receiving more and more commissions from clients outside the city since the end of the 1470s; the most renowned of these was Pope Sixtus IV, upon whose orders Botticelli was summoned to Rome in 1481. Together with his Florentine colleagues Domenico Ghirlandaio and Cosimo Rosselli and the Perugian Pietro del Perugino (Pietro di Cristoforo Vannucci), Botticelli was to decorate the walls of the papal electoral chapel – called the "Sistine Chapel" after its builder, the aforementioned Sixtus IV – with frescoes. However, it was not until the later work on it by Michelangelo, who executed the frescoes on the ceiling and the altar wall between 1508 and 1512 under Julius II, that the chapel would achieve its greatest fame.

The painting of the walls took place over an astonishingly short period of time, barely eleven months, from July, 1481 to May, 1482. The painters were each required first to execute a sample fresco; these were to be officially examined and evaluated in January, 1482. However, it was so evident at such an early stage that the frescoes would be satisfactory that by October, 1481, the artists were given the commission to execute the remaining ten stories. The pictorial programme for the chapel was comprised a cycle each from the Old and New Testament of scenes from the lives of Moses and Christ. The narratives began at the altar wall – the frescoes painted there yielding to Michelangelo's *Last Judgement* a mere thirty years later – continued along the long walls of the chapel, and ended at the entrance wall. A gallery of papal portraits was painted above these depictions, and the latter were completed underneath by representations of painted curtains. The individual scenes from the two cycles contain typological references to one another. The Old and New Testament are understood as constituting a whole, with Moses appearing as the prefiguration of Christ.

Botticelli painted three scenes within the short period of eleven months, together with the papal portraits over them and the curtain drapery underneath. The fresco which he began in July, 1481, is the third scene within the Christ cycle and depicts the *Temptation of Christ* (Illus. p. 35). Christ's threefold temptation by the Devil, as described in the Gospel according to St Matthew, can be seen in the background of the picture, with the Devil disguised as a hermit. At top left, up on the mountain, he is challenging Christ to turn stones into bread; in the centre, we see the two standing on a temple, with the Devil attempting to persuade Christ to cast Himself down; on the right-hand side, finally, he is showing the Son of God the splendour of the world's riches, over which he is offering to make Him master. However, Christ drives away the Devil, who ultimately reveals his true devilish form. On the right in the background, three angels have prepared a table for the celebration of the Eucharist, a scene which only becomes comprehensible when seen in conjunction with the event in the foreground of the

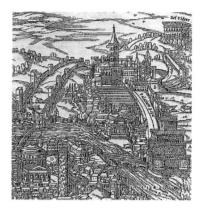

Detail from a City Plan of Rome, 16th century
The engraving shows the Pantheon on the left, the Castel Sant'Angelo on the right next to the Tiber, the Vatican Palace above it and the old Basilica of St Peter. The Belvedere Villa can be recognized upon the hill in the background.

The Rebellion Against the Laws of Moses
(detail, cf. p. 34)
The classical ruins in the background, while still largely visible in Botticelli's day, are completely destroyed nowadays. They constitute the remains of a backdrop for waterworks which had been constructed by Emperor Septimius Severus within the bath complex on the Palatine Hill.

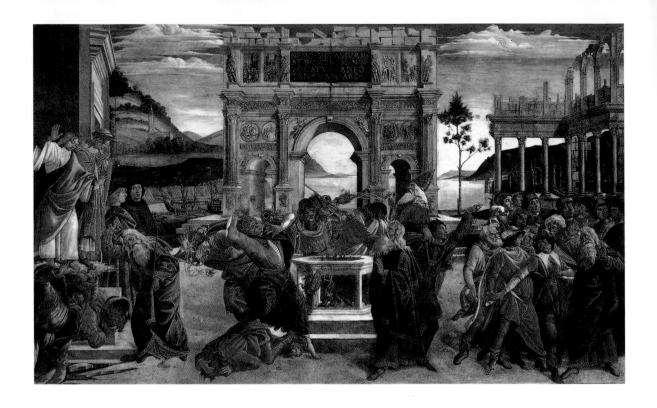

The Rebellion Against the Laws of Moses,
c. 1481/82
The fresco contains Pope Sixtus IV's warning
to all those who might dare to oppose his
papal authority: like those who rebelled in for-
mer times against the Laws of Moses, so now
those rebelling against his law were threat-
ened with God's punishment.

fresco. The unity of these two events from the point of view of content is clari-
fied by the reappearance of Christ with the three angels in the middle ground on
the left of the picture, where He is apparently explaining the incident occurring
in the foreground to the heavenly messengers. We are concerned here with the
celebration of a Jewish sacrifice, conducted daily before the Temple in accord-
ance with ancient custom. The high priest is receiving the blood-filled sacrificial
bowl, while several people are bringing animals and wood as offerings. At first
sight, the inclusion of this Jewish sacrificial scene in the Christ cycle would ap-
pear extremely puzzling; however, its explanation may be found in the typologi-
cal interpretation. The Jewish sacrifice portrayed here refers to the crucifixion of
Christ, who through His death offered up His flesh and blood for the redemption
of mankind. Christ's sacrifice is reconstructed in the celebration of the Eucharist,
alluded to here by the gift table prepared by the angels.

Among the crowd of people making up the Jewish sacrificial scene, a woman
in the left-hand foreground who is carrying on her head a bowl with hens in it
strikes us as familiar. This figure is a copy of Abra, the maid in the small panel
of *The Return of Judith to Bethulia*, which Botticelli had painted about a decade
before (Illus. p. 17, top). The posture of the woman carrying wood in the right-
hand foreground may also be derived from this picture. These similarities lead
to the assumption that Botticelli kept sketches of his compositions and figures
so as to have a stock of motifs upon which he could then draw for his later pic-
torial creations.

One of the most important frescoes in the entire Sistine Chapel is Botticelli's
Rebellion Against the Laws of Moses (Illus. p. 34), its message providing the key
to an understanding of the chapel as a whole. The fresco reproduces three epi-

sodes, each of which depicts a rebellion by the Hebrews against God's appointed leaders, Moses and Aaron, along with the ensuing divine punishment of the agitators. On the right-hand side, the revolt of the Jews against Moses is related, the latter portrayed as an old man with a long white beard, clothed in a yellow robe and an olive-green cloak. Irritated by the various trials through which their emigration from Egypt was putting them, the Jews demanded that Moses be dismissed. They wanted a new leader, one who would take them back to Egypt, and they threatened to stone Moses; however, Joshua placed himself protectively between them and their would-be victim, as depicted in Botticelli's painting. The centre of the fresco shows the rebellion, under the leadership of Korah, of the sons of Aaron and some Levites, who, setting themselves up in defiance of Aaron's authority as high priest, also offered up incense. In the background, we see Aaron in a blue robe, swinging his incense censer with an upright posture and filled with solemn dignity, while his rivals stagger and fall to the ground with their censers at God's behest. Their punishment ensues on the left-hand side of the picture, as the rebels are swallowed up by the earth, which is breaking open under them. The two innocent sons of Korah, the ringleader of the rebels, appear floating on a cloud, exempted from the divine punishment.

The principal message of these scenes is made manifest by the inscription in the central field of the triumphal arch: "Let no man take the honour to himself except he that is called by God, as Aaron was." The fresco thus holds a warning that God's punishment will fall upon all those who oppose God's appointed leaders. This warning also contained a contemporary political reference through the portrayal of Aaron in the fresco, depicted wearing the triple-ringed tiara of the Pope and thus characterized as the papal predecessor. And indeed, the supre-

Jewish Sacrifice and the Temptation of Christ, c. 1481/82
Botticelli has portrayed the threefold temptation of Christ in the background of the fresco, where the Devil, disguised as a hermit, attempts unsuccessfully to tempt Christ to turn stones into bread, to cast Himself from the roof of a temple, and to appropriate the wealth of the world for Himself.

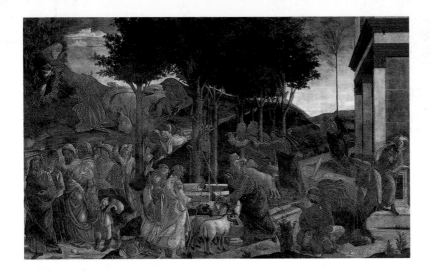

macy of the Pope and his position of ultimate authority over the Church was
being increasingly questioned at this time, with the demand becoming ever
more insistent that a general council be granted greater authority over the Pope.
However, the papal claims to leadership were God-given. Their origin lay in
Christ giving Peter the keys to the kingdom of heaven and thereby granting him
primacy over the young Church. Perugino painted this crucial element of the
doctrine on papal supremacy immediately opposite Botticelli's fresco. The di-
rect confrontation of the two depictions illustrates their unity from the point of
view of content: let no one dare to attack the authority of the Pope, God-given
and legitimized by Christ handing over the keys to Peter, lest he be overtaken by
God's punishment, as were once Korah and his supporters. Seen against this
background, the typological positioning in the Sistine Chapel of the Moses and
Christ cycles takes on a political dimension, one going beyond a mere illustrat-
ing of the correspondences between Old and New Testament. Sixtus IV was em-
ploying a precisely conceived programme to illustrate through the entire cycle
the legitimacy of his papal authority, running from Moses, via Christ, to Peter,
whose ultimate authority, conferred by Christ, finds its continuation in the
Popes. The portraits of the latter above the narrative depictions served emphat-
ically to illustrate the ancestral line of their God-given authority.

The papal claims to power were not restricted to primacy within the Church
alone, however, but included the superiority of spiritual over temporal author-
ity, something which had constituted the principal bone of contention be-
tween Pope and Emperor since the Middle Ages. The two most important
scenes from the fresco cycle in the Sistine chapel, Perugino's *Christ Gives the
Keys to Peter* and Botticelli's *The Rebellion Against the Laws of Moses*, both
reveal in the background the triumphal arch of Constantine, the first Christian
emperor, who gave the Pope temporal power over the Roman western world
The triumphal arch serves here as a prominent allusion to the power of the
Pope, granted him by the Emperor. Sixtus IV was thereby not only illustrating
his position in a line of succession starting in the Old Testament and continu-
ing through the New Testament up to contemporary times, but was simultan-
eously declaring his view of himself as the legitimate successor to the Roman
emperorship.

ILLUSTRATION TOP AND DETAIL PAGE 37:
Scenes from the Life of Moses, c. 1481/82
Here too the principal character of the picture
is portrayed in events and scenes from differ-
ent points in time. The enlarged detail illustra-
tion contains two scenes: at God's bidding,
Moses is taking off his sandals (top left), and
is watering the sheep of Jethro's daughters
(bottom right), one of whom is to become
his wife.

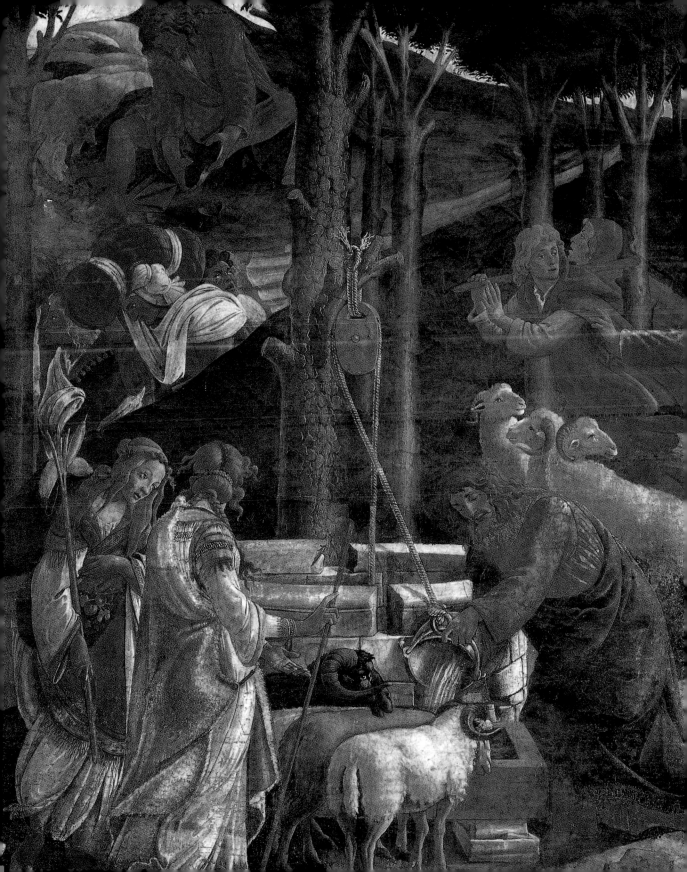

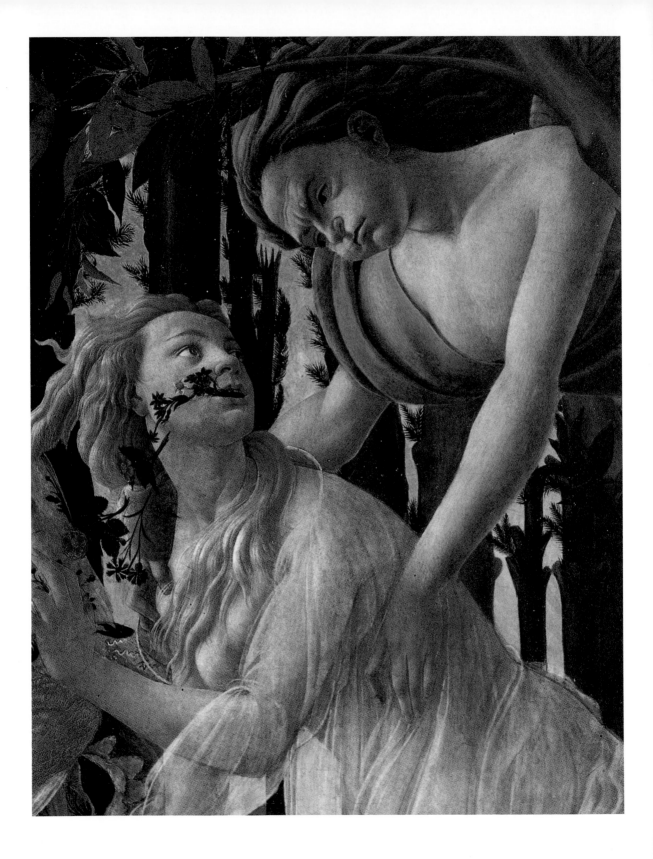

The High Ideal of Love

After returning from Rome in the spring of 1482, Botticelli executed a series of mythological paintings in the course of the decade which constitute the basis of his fame as an artist today. One of the best known of these paintings, if also without doubt the most puzzling and most discussed among them, is *The Primavera* (Illus. p.40), the exact meaning of which remains unclear to this day. For a long time it was assumed that the picture had been painted for Lorenzo the Magnificent, ruler of Florence at the time. However, this supposition has been disproved by recent studies. According to a recently discovered inventory, in 1499 the painting could be found in the Florentine city palace of Lorenzo di Pierfrancesco, a cousin twice removed of Lorenzo the Magnificent. In all probability, therefore, the painting was executed for this same Lorenzo di Pierfrancesco, from the younger branch of the Medici family. After the death of his father, this man grew up in the care of Lorenzo the Magnificent, who designated Giorgio Antonio Vespucci, Botticelli's neighbour and greatest admirer, as one of his charge's tutors. The young Lorenzo di Pierfrancesco will doubtless have heard via this man of Botticelli, who was to become his preferred painter.

We know from the aforementioned inventory that Botticelli's *Primavera* was to be found in an anteroom to Lorenzo di Pierfrancesco's bed-chamber. The picture was surrounded by a white frame and hung directly above the back-rest of a sofa, which would explain not only the length of the painting but also the sharply rising perspective of the meadow on which the eight figures in the picture appear. According to the inventory, two further paintings hung in the room, namely a *Virgin and Child* by an unknown painter and Botticelli's *Pallas and the Centaur* (Illus. p.44), placed over the door as a sopraporta. We will see that all three paintings were interrelated from the point of view of content and constituted a unity.

As indicated by the picture's title – itself known to have been in use by the 16th century – *Primavera* represents the arrival and celebration of Spring. Venus, Goddess of Love, appears in the middle of an orange grove, on a meadow adorned with flowers; overhead, her son, Amor, his eyes blindfolded, is shooting his arrows of love (Illus. p.43). Mistress of this grove, Venus has fallen back a little, as if wishing to give her retinue the opportunity to overtake her. The posture and movement of the pictorial figures are echoed by the form of the trees, resulting in a harmonious unity of man and nature. The erect stature of the orange trees echoes the figures standing upright beneath them, while the bending laurel trees on the right-hand side imitate the posture of the fleeing nymph. The orange trees come together over Venus' head to form a semicircular arch; halo-like, it surrounds the Goddess as the primary figure in the picture.

Venus appears in her garden, which Angelo Poliziano, the Medici court poet, portrayed in his verse as the place of eternal spring and peace. His poetic de-

Primavera (detail, cf. p.40)
Almost 500 different kinds of plants – 190 of them flowers – have been identified in the picture.

Primavera (detail, cf. p.40)
Botticelli has reproduced here a mythological tale passed down by Ovid, the classical poet: Zephyrus, God of Winds, is pursuing the nymph Chloris and transforming her into Flora, Goddess of Flowers and Spring.

scriptions may have provided Botticelli with the model for his painting. Thus entrance is permitted Zephyrus, the gentle wind who bathes the meadows in dew, wraps them in sweet scents and clothes the earth with innumerable flowers. The God of Winds appears on the right-hand side of the picture as a bluish-green winged being. He is powerfully filling his cheeks, so as to pour out his warm breezes (Illus. p. 38). However, Zephyrus' intentions are revealed as being less peaceful than Poliziano describes them. Instead, the God of Winds is forcing his

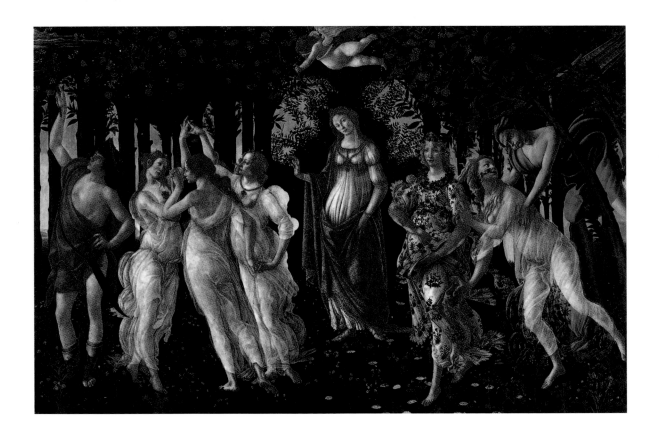

Primavera, c. 1482
The picture shows the realm of Venus, Goddess of Love (centre), in which Love and Spring with her abundance of flowers are arriving. The painting was executed for Lorenzo di Pierfrancesco de' Medici, probably on the occasion of his wedding in 1482.

way into the garden, causing the trees to bend. He is pursuing a nymph clad in transparent garments, who is turning around fearfully to look at him. Flowers are unfolding from her mouth, mingling with those lavishly adorning the robe of the woman pacing along next to her. The latter is reaching with her hand into her gathered-up dress, in order to strew the abundance of roses collected therein throughout the garden. The key to this apparently puzzling scene may be found in a written source from antiquity, namely the "Fasti", a Roman calendar of festivals by Ovid. In his work, the poet portrays the beginning of spring as the transformation of the nymph Chloris into Flora, Goddess of Flowers: "Once I was Chloris, who am now called Flora", the nymph commences her account, as flowers stream forth from her mouth. Zephyrus, so she laments, was fired with wild passion upon catching sight of her, pursued her, and took her by force. Since he regretted the violence of his actions, however, he transformed her into

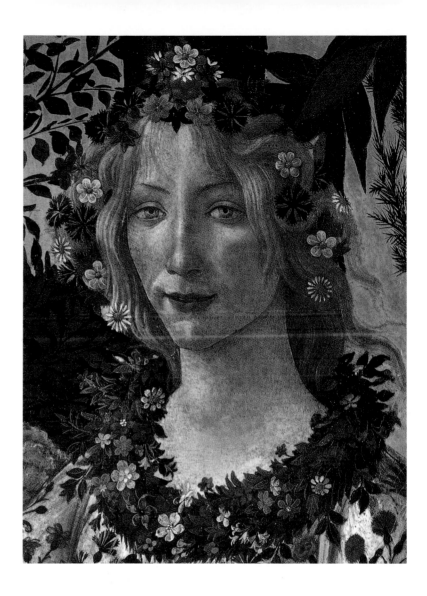

Primavera (detail, cf. p. 40)
Flora, Goddess of Flowers and Spring is garlanded with innumerable flowers, identifying her as the goddess from whom flowers come.

the Flower-Goddess of Spring. The subject matter of the three-figure group on the right-hand side of the picture is thus the arrival of spring as portrayed by Ovid in his calendar. This explains why the garments of the two female figures are blowing in different directions, since we can now understand them as representing two separate moments in Ovid's narrative and thus occurring at different points in time.

The sensual, violent nature of Zephyrus, aflame with passion, something so alien to Poliziano's poem, may be encountered in a further written source, one which will similarly have served as a model for Botticelli's representation. We are concerned here with the philosophical poem "De Rerum Natura" by Lucretius, the classical poet and philosopher, who describes the awakening of sensual, physical love within the context of the arrival of spring, and thus also that of Zephyrus:

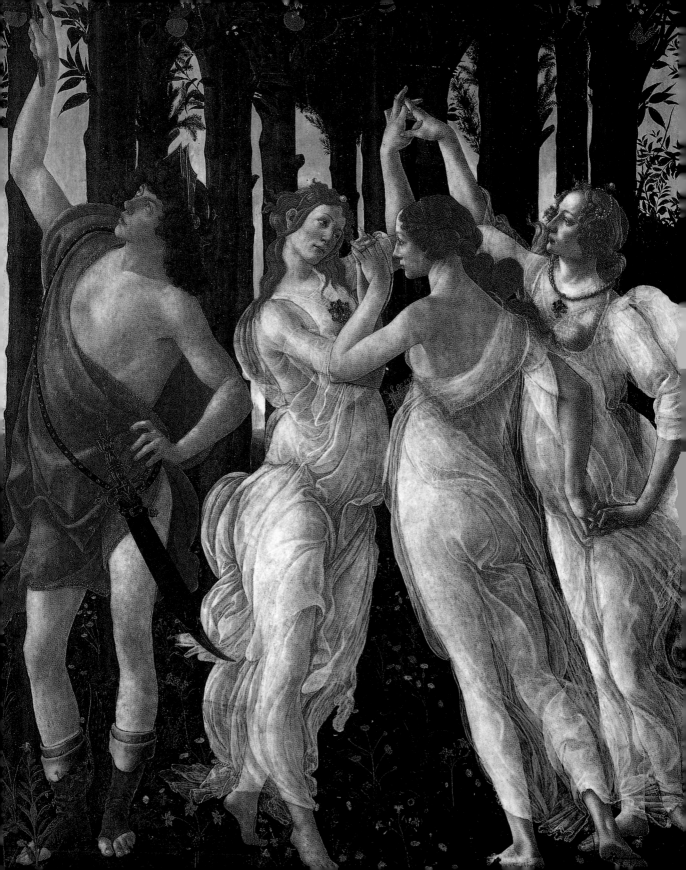

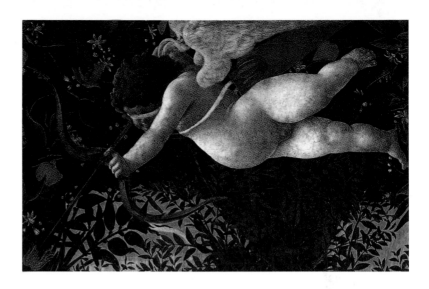

For when once the face of the spring day is revealed and the teeming breeze of the west wind [= Zephyrus] is loosed from prison and blows strong, first the birds of the air herald thee, goddess, and thine approach, their hearts thrilled with thy might.... so surely enchained by delight... thou dost strike fond love into the hearts of all, and makest them in hot desire to renew the stock of their races, each after his own kind. (I.10–20)

On the left-hand side of the picture, we see the three Graces, companions of Venus, dancing a roundelay in a charming manner (Illus. p.42). They are followed by Mercury, Messenger of the Gods, with whom the painting concludes on the left. He may be identified by means of his winged shoes, and also by the staff in his raised right hand, the so-called caduceus, around which two snakes are winding themselves. Classical mythology has it that Mercury used his staff to separate two fighting snakes, upon which the staff became the symbol of peace. And it is in this sense that it should be understood in Botticelli's painting: Mercury is using it to drive away some clouds which are threatening to force their way into Venus' garden. Thus it is that he becomes the protector of the garden, in which there are no clouds and where eternal peace reigns. Mercury's ability to defend the grove as its guardian is further underlined by the conspicuous nature with which his sword is displayed, a symbol that he is capable of driving away enemies at any time.

No single classical or contemporary written source can be found for Venus' retinue as seen in Botticelli's painting. Instead, the representation follows several written sources, which together will have served as models for the fashioning of individual persons themselves or explain their relationship to Venus. There can be no doubt, however, that the philosophical poem mentioned above, Lucretius' "De Rerum Natura", will have functioned as Botticelli's primary source, since not only the three Graces but all of the figures contained in the picture may be found therein:

Spring goes on her way and Venus, and before them treads Venus' winged harbinger; and following close on the steps of Zephyrus, mother Flora strews and fills all the way before them with glorious colours and scents.... Thou, goddess, thou dost turn to flight the winds and the clouds of heaven, thou at thy coming; for thee earth, the quaint artificer, puts forth her sweet-scented flowers; for thee the levels of ocean smile, and the sky, its anger past, gleams with spreading light. (V.737–740; I.6–9)

ILLUSTRATIONS TOP AND PAGE 42:
Primavera (details, cf. p.40)
Blindfolded, Amor, son of Venus, is shooting his arrows of love. The flame at the arrow's tip symbolizes the intensity of the feelings of love which he causes.

The three Graces, companions of Venus, Goddess of Love, are dancing a roundelay. Next to them stands Mercury, Messenger of the Gods, protecting the garden of Venus from intruders.

43

However, the painting would appear to hold yet another pictorial meaning, one which goes beyond a simple depiction of spring in the garden of Venus and is able to lead us to a deeper understanding of the picture. Before uncovering this pictorial content, we must first turn our attention to Botticelli's painting *Pallas and the Centaur* (Illus. p.44), which hung together with *Primavera* in the city palace of Lorenzo di Pierfrancesco. It shows Pallas Athene, Goddess of Wisdom, standing next to a centaur. Athene's attributes include the lance, reinterpreted by Botticelli as a halberd, and the branches, entwined around her upper body and arms, of the tree sacred to her, the olive. As with *Primavera*, we are aware of no mythological narrative or classical written source which could have served Botticelli as a model for the combination of the centaur and Athene. However, the meaning may be reconstructed from the events portrayed in the picture, together with the references in this work to *Primavera*.

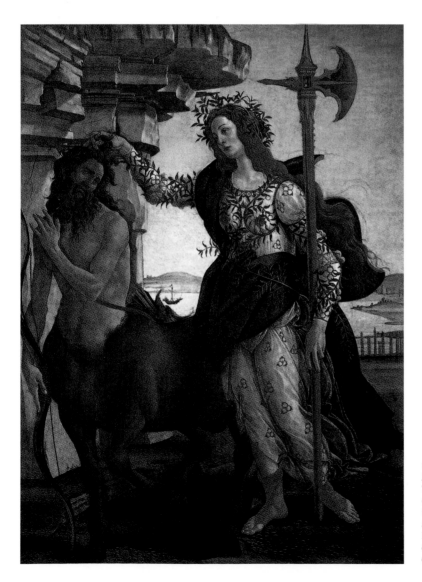

ILLUSTRATION LEFT AND DETAIL PAGE 45 BOTTOM:
Pallas and the Centaur, c. 1482
This picture represents the victory of chastity over lust. Botticelli has used the emblem of the Medici family, three interlinked rings, as an ornamental element on the garment of Pallas, Goddess of Wisdom. It is fair to deduce, therefore, that the painting was executed for a member of the Medici family.

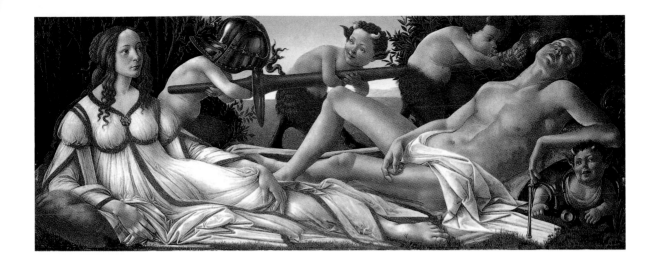

Venus and Mars, c. 1483
Venus, Goddess of Love, has vanquished
Mars, God of War. While he lies there, sunk
in a deep sleep, she watches him with a steady
and attentive gaze, keeping him under her
supervision.

Pallas Athene and the centaur are in an enclosed area, bordered in the background by a palisade. Athene clearly has the function of a guardian, as indicated by the halberd in her hand, a weapon commonly used at that time only by sentries. The centaur would thus appear to have forced an entry into an area forbidden to him. However, Pallas Athene has surprised him just as he is in the process of testing his strung bow – note his middle finger, still bent – thereafter to let fly one of the arrows in his quiver. She has grasped his hair in order to prevent him from carrying out his intention, causing him to turn towards the Goddess, his face twisted with pain. Yet what forbidden territory has the centaur dared to enter? The answer to this question lies in the interpretation of the centaur as the personification of lust, his main pleasure consisting of hunting innocent nymphs – presumably his intention in Botticelli's painting as well. The picture would thus represent the victory of chastity over lust.

If we now seek the deeper meaning behind these paintings, it would appear that both illustrate the idea of love as developed by Marsilio Ficino, philosopher at the court of the Medici, who combined platonic ideas with the Christian belief to produce a new, Neoplatonic view of the world. Ficino saw the nature of love as a duality of physical, earthly desire, on the one hand, and spiritual longing directed towards God, on the other. These he saw as diametrically opposing each other in the form of the conflict of sensuality and intellect, of matter and spirit. Ficino described man's ideal journey through life as a striving to escape from sensual passion and acquire a cerebral desire for enlightenment and wisdom in God.

Ficino's concept of love would appear to be reflected in Botticelli's two paintings. Zephyrus embodies unbridled passion, as also described by Lucretius in the passage quoted above on the arrival of spring and Zephyrus. The God of Winds is forcing his way into the events of the picture from the right, his wing and left arm conveying the idea of downward motion which is directed down along the nymph's right arm and Flora's leg. In this manner, Botticelli was clearly demonstrating the carnal desires of Zephyrus, desires fixed on earthly things. The renunciation of this physical passion, as suggested by Ficino for mankind, is performed by the middle figure of the three Graces: totally without ornamentation, she is turning her back on the observer, while Amor aims at her with his arrow of passion. She has turned away both from her companions' game and from the

events surrounding Zephyrus; lost in thought, she is looking at Mercury, whose posture and gaze point upwards to the left, out of the painting. However, Mercury's direction of movement leads not into an empty space but on to the painting of *Pallas and the Centaur*, which originally hung to the left of *Primavera*, over a door. Thus, the movement performed by the Grace reaches its climax in Pallas Athene. As Goddess of Wisdom, she embodies a love orientated towards knowledge. Zephyrus allows his carnal desires and lust free rein, whereas Athene brings these under control in the figure of the centaur. The direction of movement culminating in the Goddess is not continued to the left, for the picture ends abruptly on this side with a cliff. The only way out is upwards, following the tip of her halberd, towards the heavenly sphere, where ultimate knowledge through God is waiting. Mercury's function here is that of mediator between the middle figure of the three Graces and Pallas Athene. He takes up the gaze of the Grace and passes it on to the Goddess, in accordance with his role as Messenger of the Gods, bearer of messages. The invisible source of light for *Primavera* may also be sought on the left-hand side, Botticelli illustrating in this way the divine knowledge and "enlightenment" emanating from there.

The Christian orientation of love expressed in these two paintings will originally have reached its culmination in the third picture of those comprising the room's furnishings, the afore-mentioned portrayal of the Virgin and Christ child, in which the love of God, who sacrificed His only son for mankind, finds clear, uncoded expression.

The figures display an accomplished beauty, loveliness and gracefulness, such as correspond to the idealization of love which they embody and which remove them from the earthly sphere. They have no contact with the ground; instead, they float gently over the earth. Despite their bodily proximity, they do not seem to touch one another, particularly striking in the case of the three Graces in *The Primavera*, who remain curiously isolated in their roundelay despite their loose holding of hands. This negates the physical presence of the figures, who appear before the observer as if they were visions and are at a remove from him despite their great attraction.

The stylistic composition of these pictures reveals their temporal proximity to the Roman frescoes. We can point here to the striking similarities between Jethro's daughters (Illus. p. 37) and the three Graces (Illus. p. 42), who could almost be sisters. All of them are distinguished by their light-blonde hair, imaginatively braided, their delicately overcast, melancholic facial expression, and their shy gracefulness. Thus, it is conceivable that the paintings *Primavera* and *Pallas and the Centaur* were executed shortly after Botticelli's return from Rome in 1482. Lorenzo di Pierfrancesco, in whose palace they originally hung, celebrated his marriage in July, 1482. It is possible that the pictures were painted for his wedding, a fact which would bestow upon their subject-matter, love, a topical element.

Venus and Mars, a painting completed after *The Primavera* and probably executed around 1483, also takes love as its dominant theme (Illus. p. 45). The central figures of the picture are Venus and Mars, God of War, who are lying facing each other in a grotto of myrtle trees. The myrtles, sacred to Venus, make it clear that the enclosed area is the territory of the Goddess of Love. Half-sitting, she is looking with an assured and attentive gaze at Mars, who is sunk in the deepest of sleeps – not even the satyrs playing around him are capable of waking him. The painting represents the triumph of Venus, Goddess of Love, over Mars, God of War, whom she has successfully distracted from his aggressive activities, so that the little satyrs are utilizing his weapons as

Venus and Mars (detail, cf. p. 45)
Nothing is capable of disturbing Mars' deep sleep. The satyrs are taking advantage of the opportunity to amuse themselves. The wasps buzzing over Mars' head should probably be interpreted as a reference to the person commissioning the painting, a member of the Vespucci family: inspired by the Vespucci/vespa (Italian for wasp) play on words, one branch of the family had incorporated wasps into its coat of arms.

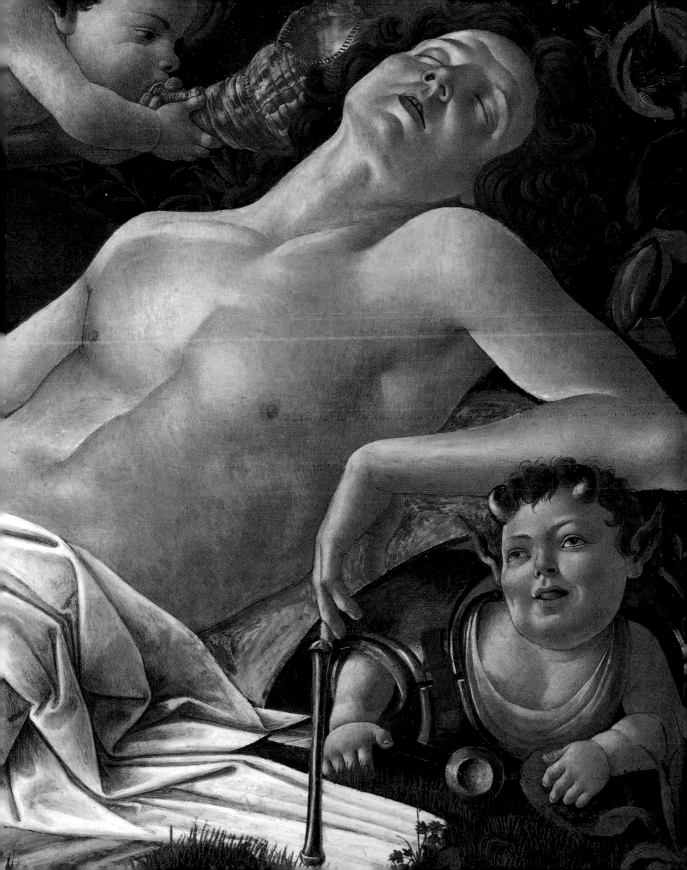

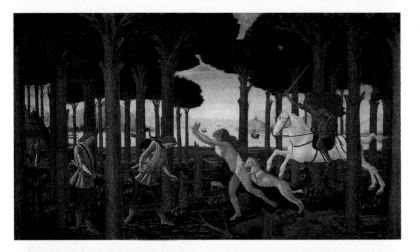

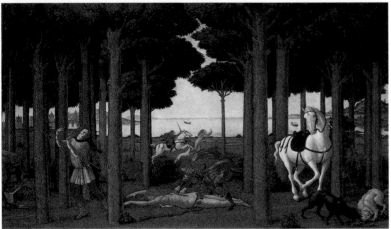

toys. Here too, however, we are concerned less with the triumph of love over warlike violence than with the surmounting of sensual desire through one's enlightened love of God. In a manner similar to that encountered in *Primavera*, the painting depicts the duality of love as expounded by Ficino. As God of War, Mars embodies violent desire; in contrast to Venus, he is portrayed almost naked. One of the satyrs is vainly attempting to wake Mars by blowing in his ear through a seashell (Illus. p. 47). The satyrs were regarded as figures of lust, something which they are trying to awaken in Mars here. In Venus, on the other hand, this sensual longing has been overcome. She is clad in a white gown embellished with gold braid trimming, held together over her breasts by a brooch. This piece of jewellery is made up of pearls, which should be understood as symbolizing her chastity.

Botticelli has employed humour in portraying the little satyrs, who are whiling away the time with Mars' martial instruments. According to classical mythology, these companions of Bacchus, God of Wine, were provided with horns, goat's feet, and tails, in the manner in which Botticelli has painted them. Two of them have seized Mars' lance, intending to secretly carry it away. The rearmost of these two has pulled the God of War's helmet over his own head, despite its being far too big for him, while one of the others has crept into Mars' breast-

The Story of Nastagio degli Onesti, 1483
The four paintings take a story of courtly love from Giovanni Boccaccio's "Decamerone" as their subject. Nastagio degli Onesti, a knight from Ravenna, whose beloved initially refused to marry him, finally weds her after all (p. 49, bottom).

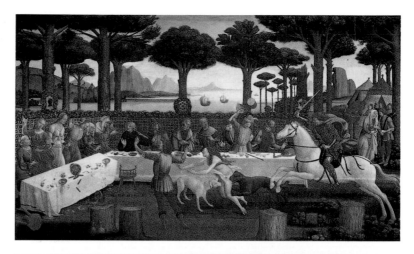

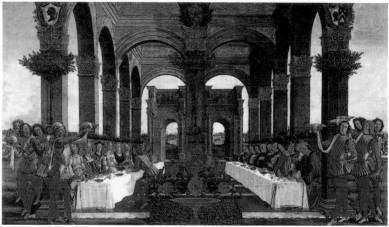

First of all, however, he must remind her of
the eternal agony in hell of another merciless
woman, one who had also refused marriage
(p. 49, top): her rejected lover had to pursue
her until he had caught up with her, killed her,
torn out her heart and intestines and fed them
to his dogs (p. 48, bottom).

plate on the right-hand side and is peeping out with a mischievous look on his
face. Botticelli has taken inspiration with regard to satyrs playing with weapons
from a classical painting by the artist Aëtion, described by the classical poet
Lucian. This picture showed the wedding of Alexander and Roxane, and Lucian
outlines how the satyrs play with Alexander's weapons, which he has laid aside.
Yet it is not only in the narrative composition of his scene that Botticelli has
allowed himself to be prompted by Lucian; the satyrs themselves may be traced
back to the poet's description, since they constitute one of the first pictorial rep-
resentations of this kind in the Renaissance period.

The subject of love renders it likely that this painting too served as a wed-
ding picture. In all probability, the person commissioning it was of the Ves-
pucci family. This is indicated by the wasps buzzing over Mars' head: a
branch of the family, inspired by the Vespucci/vespa (Italian for wasp) play on
words, had incorporated wasps into its coat of arms, and the depiction of
wasps in the picture could be understood as containing a reference to this. The
close relations between the Vespucci and Medici families would also explain
the parallels between the pictorial messages of *Venus and Mars* and the two
paintings commissioned by Lorenzo di Pierfrancesco, *Primavera* and *Pallas
and the Centaur*.

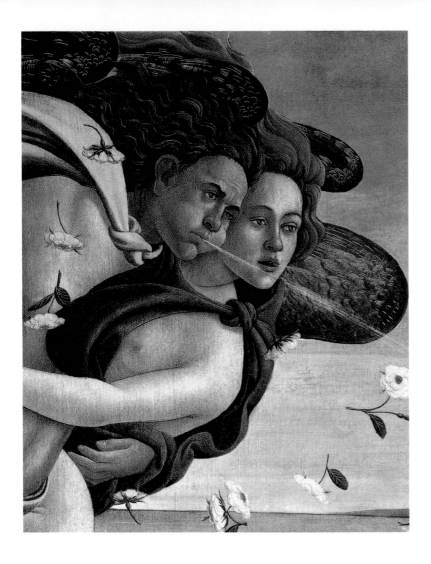

In the same year in which Botticelli probably executed *Venus and Mars*, the artist painted the four long panels with scenes from a story of courtly love taken from Boccaccio's "Decamerone" (Illus. pp. 48, 49). Antonio Pucci, the Florentine merchant, commissioned the paintings for the wedding of his son Giannozzo in 1483, an event for which no less a figure than Lorenzo the Magnificent was the negotiator. We know from the inventory of the Pucci palace that the pictures functioned as wall decorations in the marriage-chamber. The subject matter, presumably selected by Antonio Pucci himself, is concerned with the story of Nastagio degli Onesti, a knight of Ravenna, who seeks solitude in a pine wood – as may be seen in the first painting – in order to mourn for his beloved, who has refused to marry him. Suddenly, he observes a naked woman pursued by a young knight and attacked by a dog. What follows this terrible scene is contained in Botticelli's second painting: the knight kills the helpless woman and tears out her intestines and heart, feeding them to his dogs, who appear on the right-hand side in the foreground. Thereafter, the woman comes to her feet again, unscathed, and the dreadful course of events begins all over again, as

The Birth of Venus (detail, cf. p. 51)
Zephyrus, God of Winds, and the gentle breeze Aura have their arms tightly around each other so that they may together blow Venus, Goddess of Love, ashore.

may be seen in the background of the picture. We read in Boccaccio's account that Nastagio asks the knight for an explanation of this affair, as puzzling as it is horrifying. He informs Nastagio that what he has seen is the eternal punishment in hell which he and his beloved must undergo. He recounts how he committed suicide, since his beloved had constantly scorned his offer of marriage; she, for her part, received this punishment because she was so hard hearted. Shaken,

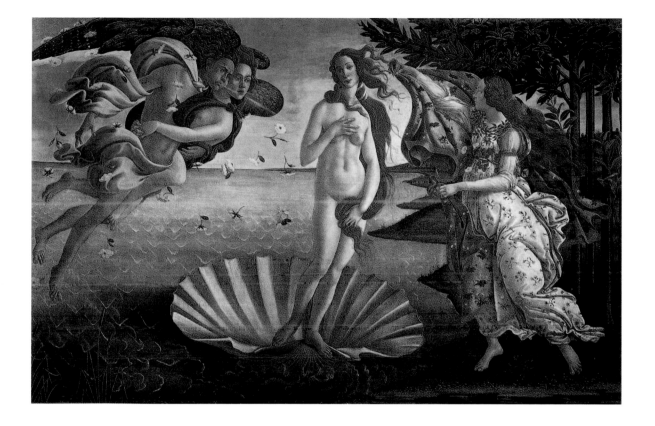

Nastagio invites his beloved to a banquet in the pine wood, as can be seen in Botticelli's third painting. The young woman suddenly appears in the midst of the feast, pursued by the dogs and the knight, and Nastagio enlightens the participants in the banquet as to the tragic story. At this, his beloved, acknowledging her own pitiless behaviour, agrees to their marriage, depicted in the final picture in front of a triumphal arch symbolizing the triumph of love. The levels of reality begin to merge in Botticelli's third and fourth pictures. The coats of arms of Giannozzo and his wife, and also those of their negotiator, Lorenzo the Magnificent, appear on the trunks of the pine trees and above the capitals of the columns. In each case, the coat of arms of the Pucci family may be seen on the left-hand side, that of the Medici in the centre, and that of the newly founded Pucci-Bini family on the right. Several portraits can also be detected among the participants in the banquet. Antonio Pucci, father of the bridegroom, is depicted in the third picture beneath the Medici coat of arms, for example, appearing again in the final painting as the third figure from the front on the right-hand side. The man portrayed to his right is probably Lorenzo the Magnificent.

The Birth of Venus, c. 1485
According to classical mythology, Venus, Goddess of Love, sprang from the foaming waters of the sea. Botticelli portrays her here standing on a seashell floating in the water. She is being blown to land by two wind deities; one of the Horae, Goddesses of the Seasons, is holding a robe in which to wrap her.

The Birth of Venus (detail, cf. p. 51)
The robe held ready for the Goddess of Love is embellished with spring flowers. Spring is the season attributed to Venus, the time of love – then as today.

The Birth of Venus (detail, cf. p. 51)
The hard modelling of the white shimmering flesh colour gives Venus the appearance of a statue. Botticelli has gone over the contours with a black line, causing them to stand out sharply from the surface of the picture and lending them a curious coldness and clarity.

Botticelli's famous painting of *The Birth of Venus* (Illus. p. 51) was executed in the middle of the 1480s. At the start of the 16th century, the painting hung together with *Primavera* in the country villa of the Medici in Castello. For this reason, it was assumed that both paintings had been done as counterparts for Lorenzo the Magnificent. Since the discovery of the inventory mentioned above, however, we know that *Primavera* hung in the city palace of Lorenzo di Pierfrancesco, and that its counterpart was to be found in the painting of *Pallas and the Centaur*. Given that *The Birth of Venus* can be proven to have been in the possession of the Medici by the beginning of the 16th century, it would appear quite likely that it was also painted for this family. On the other hand, we do not know which member of the family commissioned the painting, nor where it originally hung. Be that as it may, we can assume that the picture was intended for the decoration of a country villa, both on technical grounds and because of its content. For example, *The Birth of Venus* is painted on canvas. The cost involved in creating a painting on canvas was considerably less than that required for a panel painting on wood, and the former were accordingly used for the decoration of country villas, where social functions and ostentation were of less importance than in the city palaces of the families. The country villas served as refuges from the noise, heat and hectic business of the city. Here one was free to relax and enjoy the country life, and the decoration of these villas was in line with this desire for peace and recreation. Arcadian subjects of a cheerful character were preferred for the adornment of the rooms. We know from contemporary accounts, for example, that the paintings hanging over the doors of the main rooms in the Medici country villa in Careggi depicted landscapes with animals, women bathing, singers, and people dancing, bathed in sunlight. It is against this background that *The Birth of Venus* should also be seen.

Venus is standing in the centre of the picture on a seashell floating in the water: according to classical mythology, she sprang from the foaming waters of the sea. This froth had formed around the genitals of Uranus, God of the Sky, his son Cronus having cut them off and thrown them into the sea as an act of revenge for the cruelty perpetrated by his father. The figure of Venus appears in Botticelli's painting almost like a classical statue. The hard modelling of the white shimmering flesh colour is reminiscent of marble, while her posture recalls the classical sculpture of *Venus Pudica*, modest Venus. Botticelli has gone over the contours of the figure with a black line, causing them to stand out sharply from the surface of the picture and emphasizing their curious clarity and coldness. Roses are floating down from the sky: according to classical legend, their origin coincided with the birth of Venus.

Despite the title of the painting, however, it is not the birth of the Goddess which is depicted, but rather her coming ashore on the island of Cythera, where she is supposed to have landed following her birth – thus Homer, the classical poet, in his hymn to Venus, which served Botticelli as literary source for his picture. On the left-hand side flies Zephyrus, God of Winds, the arms of the breeze Aura wrapped tightly around him. The two of them are endeavouring to blow the Goddess of Love ashore (Illus. p. 50). There, Venus is being received by one of the Horae, Goddesses of the Seasons, who is spreading out a robe for her. The flowers which embellish the garments (Illus. p. 52) distinguish this Hora as the Goddess of Spring.

The series of mythological paintings is brought to a close by two frescoes which originally decorated the country villa of Lemmi, near Florence, and were removed from their original location in 1873 (Illus. pp. 54, 55). The owner of this villa was Giovanni Tornabuoni, uncle of Lorenzo the Magnificent and head

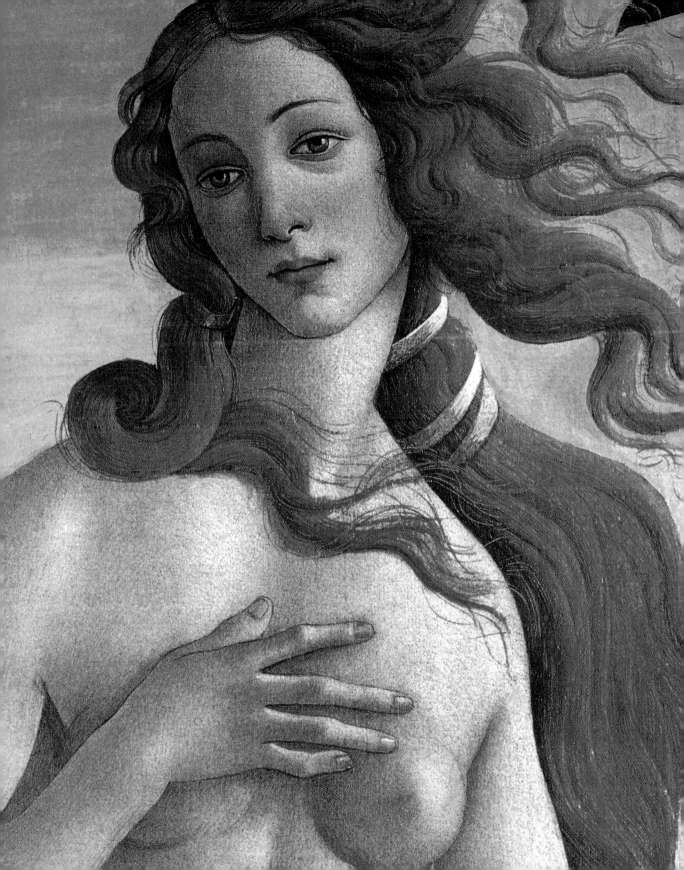

of the important Rome branch of the Medici bank. Giovanni commissioned the frescoes for the wedding of his son Lorenzo, who married Giovanna of the old and respected Albizzi family in 1486. The two frescoes originally hung facing each other, and depicted the bride and bridegroom being received into the circle of mythological and allegorical figures respectively. Thus we see Giovanna Tornabuoni being received by Venus and her companions, the three Graces (Illus. p. 54). Venus is laying roses – symbolizing beauty and love – in the white cloth held open by Giovanna. These are the gifts granted her as a bride by the Goddess.

On the facing page, we see Lorenzo Tornabuoni being led by the personification of Grammar into the circle of the Seven Liberal Arts, over which Prudentia (Wisdom) sits enthroned (Illus. p. 55). In antiquity, the study of the seven liberal arts constituted the basic knowledge upon which all further studies built. The individual Arts may be recognized by means of their attributes: Rhetoric, in the left background, through her scroll; Logic through her scorpion, whose pincers convey the idea of the polarizing positions of dialectic thought; Arithmetic through a sheet with mathematical formulae. These are followed by Wisdom on a raised seat, then Geometry with a rule triangle, Astronomy with her celestial sphere, and finally Music, with a tambourine and a small portative organ. Grammar has been portrayed, in accordance with tradition, as a teacher accompanied by a child. Here she is escorting Lorenzo to the Arts. He is being greeted by Wisdom, who bears an olive staff in her left hand, to be understood as symbolizing the harmony prevailing among the Arts. Lorenzo's introduction into the circle of the Liberal Arts testifies to his broad education: before entering into the banking business – he was to succeed his father as head of the Rome branch – he had been taught literature, languages, and philosophy. Lorenzo's affinity for numbers, on which the emphasis of his education will surely have been placed, is conveyed by the hand which Arithmetic holds out to him in greeting; moreover, she is the only one of the Liberal Arts to regard him attentively and – together with Wisdom – to explicitly bid him welcome.

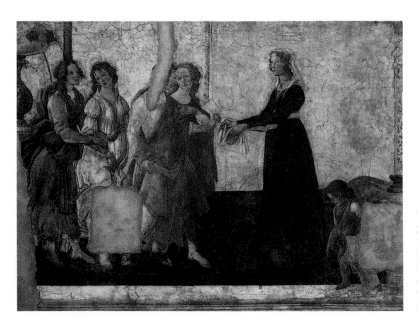

Giovanna degli Albizzi Receiving a Gift of Flowers from Venus, 1486
The two frescoes on this and the facing page formerly decorated the country villa of Lemmi near Florence. Botticelli painted them for the wedding of Lorenzo Tornabuoni to Giovanna degli Albizzi. The putti appearing at the edge of the two pictures originally held the coats of arms of the bridal couple.

The mythological paintings of the 1480s constitute an unusually homogeneous group, not only in pictorial content but also in stylistic expression. It is probable that they functioned as wedding pictures. The predominant subject is the elevation of love, as illustrated by the idealized female figure. The female forms are distinguished by their beauty, loveliness and gracefulness, qualities that are not found to such a degree in religious paintings of this period and which create a sense of distance between them and the observer through their perfection.

Lorenzo Tornabuoni Presented by Grammar to Prudentia and the other Liberal Arts, 1486

Beautiful Madonnas for Wealthy Patrons

It is all too easy for one's view of Botticelli's religious works from the 1480s to be obscured by the famous mythological paintings which he did during the same period; yet the former are among the finest altarpieces that he executed. The *Adoration of the Magi*, which Botticelli perhaps painted while still living in Rome during 1481/82, represents the beginning of this series (Illus. p.58). One of the elements suggesting this is the background landscape, permeated with winding roads; its colours reveal a richness unusual for Botticelli, with deep greens and browns predominating. One is reminded of the scenery in Umbria, and this kind of landscape indeed indicates the influence exerted upon Botticelli by Perugino – who was from Umbria – while they were working together on the frescoes of the Sistine Chapel. A further intimation that the picture was perhaps done during Botticelli's stay in Rome can be seen in the groom in the background on the right who is attempting to bring his horse under control; Botticelli probably adapted this motif from the classical sculptures of the Dioscuri, the horse-tamers, in Rome.

In contrast to Botticelli's earlier versions of the Adoration (Illus. pp. 11, 19, 22), the Virgin and the Christ Child now form the painting's main focal point, uncontested by any of the figures accompanying them. As in the Adoration done for Guasparre del Lama (Illus. p.22), those present here are arrayed around the Virgin in a semicircle; in this picture, however, Botticelli has opened up the semicircle towards the observer, so that the latter's gaze may reach the Virgin unhindered. At the same time, all those involved, their postures and gestures, are directed towards the Mother of God, lending the painting a dramatic unity which the earlier *Adorations* lacked. The artist's recording of the figures' various reactions demonstrates once again the importance for Botticelli of Alberti's treatise on painting. The art theoretician recommended for the edification of the observer not only the greatest variation in the possible palette of emotions but also the depiction of people of differing age, together with alternation in the perspectives offered by the figures, who should be presented from various sides in three-quarter and half profile or from the front. Botticelli's wealth of variation in the fashioning of his figures fulfilled all of these demands, yet without losing the central focus of the picture's content.

One of Botticelli's most important religious paintings from this period is the so-called *Bardi Altarpiece*, in which the Virgin is depicted enthroned in an arbour niche between St John the Baptist and St John the Evangelist (Illus. p.63, bottom). Botticelli painted this altarpiece in 1484 for Giovanni d'Agnolo de'Bardi, who had been head of the London branch of the Medici bank and had now returned to his home city after twenty years in the English capital. Botticelli's work was destined for the family chapel of the Bardi in the church of Santo Spirito, which had been completed in 1482 following plans by Brunelle-

Allegory of Abundance (detail, cf. p.61)

The Virgin and Child with Six Angels (The Madonna della Melagrana), c. 1485
The title of the painting, *Madonna della Melagrana*, refers to the pomegranate which Mary is holding in her hand. It should be understood as a symbol of Christ's Passion, the wealth of seeds conveying the fullness of Christ's suffering.

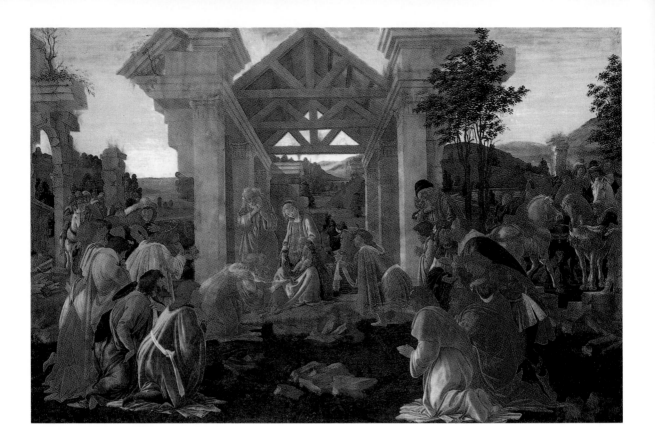

schi. It was intended that the harmony and unity of the early Renaissance struc-
ture be continued in the precisely prescribed interior of the chapel. This con-
sisted of a simple altar-table of grey pietra serena, a stone that has continued to
be cut near Florence down to the present day. The front side of the altar was
decorated with a painted panel added to it – a paliotto – while the rectangular
altarpieces, each identical in size and showing the stipulated depiction of a Vir-
gin and Child surrounded by saints, as in Botticelli's painting, stood on the
mensa.

St John the Baptist and St John the Evangelist appear here as the patron
saints of Giovanni Bardi, who had commissioned the picture; the former, in his
function as principal patron saint of the city of Florence, is assigned the place of
honour on Mary's right. He may be identified not only by the shaggy animal-
-skin, which he wore as a desert preacher, but also by the baptismal bowl lying
on the meadow beside his feet. The detailed fashioning of the meadow flowers
and the plants in the arbour niche call to mind *Primavera*, which Botticelli
painted at almost the same time (Illus. p. 40), clearly indicating the temporal
proximity of the two works.

The flowers represent a eulogy in symbolic form of the Mother of God, the
significance allotted each of them being explained by means of thin banderoles
attached to the individual plants. With reference to the roses which fill the
bowls on the back-rest of the throne bench, for example, we may read, "Like a
rose tree in Jericho"; the olive branches in the copper vases behind them bear
the comparison, "Like a beautiful olive tree in an open field". The lemon trees

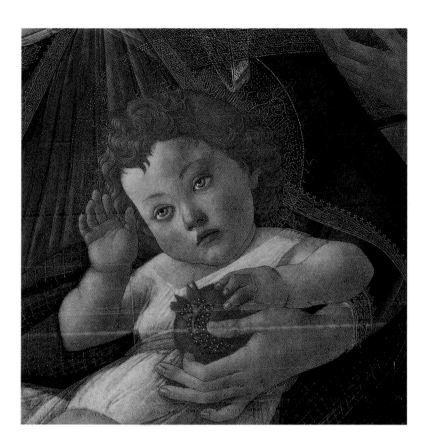

Virgin and Child with Six Angels (detail, cf. p. 56)

completing the painting on each side have the text: "I am as tall as a cedar from Lebanon." The fact that Botticelli reproduced lemon trees here instead of cedars may be explained by the common confusion of these plants during the Renaissance, resulting from the ambiguity of the Italian translation of Latin "cedrus" as both cedar and lemon tree.

The texts of the banderoles present Mary as the pure Mother of God. The belief in her immaculate conception, in the *immaculata conceptio*, had a great following in the 15th century, especially in England. Giovanni Bardi too was clearly not unaffected and prompted Botticelli to produce what was an unusual pictorial composition for the Florence of that time. The careful breaking-down of the plant symbolism through the banderoles likewise stems from a tradition that was more indigenous to the northern countries than to Italy. Giovanni Bardi had presumably seen a similar painting during his period of residence in England and brought the idea back with him to Florence.

We still have the document of payment for this altarpiece, according to which Botticelli received 78 florins and 15 soldi in payment for the execution of the painting. The sum results from payment for Botticelli's work, for which the painter was given 35 florins, and for the expensive materials, which the remaining 43 florins covered. The gold alone, the price of which amounted to 38 florins, cost Botticelli's client more than the artist's work – an indication of how much value the man commissioning the picture placed on its splendid ornamentation, since the quantity of gold to be used was his to decide. If one further considers that the monthly income of an unskilled labourer in Florence at that time

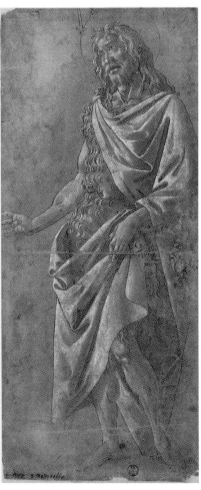

Botticelli's Drawings

"Botticelli drew frequently, to such an extent that artists went to considerable lengths after his death to follow his drawings. We have some in our (drawing) book which are executed with great skill and discernment." (Giorgio Vasari)

With the exception of Botticelli's Dante drawings (cf. Illus. pp. 76, 77), only a few have survived of the artist's many studies mentioned by Vasari in 1550. However, those which we do have, bear witness to the high quality of Botticelli's drawing skill. Their execution is remarkably detailed, and the artist made use of various techniques in order to render his work as effective as possible. This may be perceived in the *Allegory of Abundance* illustrated below, for example, who bears a cornucopia in her arm as a symbol and is accompanied by putti carrying fruit. Her posture and physiognomy are strongly reminiscent of the figures of Flora and Venus in *Primavera* (Illus. p. 40), giving the study a date some-

where in the first half of the 1480s. The proximity to *Primavera* may also be seen in the treatment of her dress, which is identical with those of the three dancing Graces. These figures are all clad in transparent garments which cling to their bodies, emphasizing their forms.

The study for *St John the Baptist* may also be dated to the 1480s. This is suggested by the great similarities between the figure in this work and that of the same name from *Bardi Altarpiece* (Illus. p. 63, bottom), in particular revealed in the pose, the physiognomy of the emaciated face, and the fashioning of the garments.

It is known that Botticelli made a collection of drawings of his compositions and figures, so as to have a stock of motifs for his later pictorial creations. However, it has proved impossible to directly link the drawings illustrated here to any of his paintings.

ILLUSTRATION PAGE 60 TOP:
Three Angels, c. 1475–80

ILLUSTRATION PAGE 60 LEFT:
Angel, c. 1485–90

ILLUSTRATION PAGE 60 RIGHT:
St John the Baptist, c. 1485

ILLUSTRATION RIGHT:
Allegory of Abundance, c. 1480

61

amounted to some two florins, the extent of Giovanni Bardi's financial outlay
becomes all the clearer. It would appear that the banking merchant was seeking
to re-establish himself in his home city in a suitable fashion by means of this al-
tarpiece, while also wishing to lend expression to his high social standing. And
indeed, he was mourned upon his death in 1488 as "a good and venerable man
in his lifetime".

It was at about the same time that Botticelli painted the *Madonna della Mela-
grana* (Illus. p.56). The picture's title is explained by the pomegranate in
Mary's hand: this should be understood as symbolizing Christ's Passion, the
wealth of seeds conveying the fullness of Christ's suffering. A comparison of
this painting with Botticelli's earlier tondo (Illus. p.26) reveals that the artist has
now arranged the angels symmetrically, thereby avoiding the compositional dif-
ficulties of the older depiction. A certain lifelessness of the figures in the picture
can nonetheless be detected; while this may also be encountered in the mytho-
logical paintings from this period, here it holds the danger of superficiality.
Mary is bowing her head in a manner that is well-nigh mechanical, and the ges-
tures and gazes of the angels make one conscious that the gentle vivaciousness
encountered in the earlier depictions is missing here.

However, Botticelli's next picture, his *Annunciation* (Illus. p.64), which can
be regarded as one of his main works from the creative period of the 1480s, is
evidence of the fact that the artist had not fallen into a general monotonousness
with respect to his representations.

Mary and the angel encounter each other in a room whose grey pietra serena
walls contrast effectively with the brilliant red, brightly contrasted slabs of the
floor. The observer's gaze passes through a doorway framed by a broad stone
jamb to fall on a seemingly northern landscape. The motion of the garments

The Virgin and Child Attended by Four Angels and by Six Saints, c. 1487

This painting originally decorated the main altar of the Florentine church of San Barnaba. The patron of the chapel in the main choir was the City of Florence. As was customary at that time, the supervision of the chapel's interior had been entrusted by the community to a guild, in this case the Guild of Apothecaries and Doctors, to which the painters also belonged. It was probably this guild who commissioned the altarpiece from Botticelli.

The Virgin and Child Enthroned between St John the Baptist and St John the Evangelist (The Bardi Altarpiece), 1484

The merchant Giovanni d'Agnolo de' Bardi paid Botticelli more than 78 florins for this picture. (The monthly income of an unskilled labourer in Florence comprised some two florins at the time.) However, the painter received only 35 florins for his work, the remainder covered the cost of his materials.

worn by the angel kneeling before Mary indicates the momentum of the movement which he has just completed; standing, the Virgin is leaning towards the angel in a curiously twisted posture, her body thereby describing the form of an "S" akin to that of a Gothic sculpture. She is stretching out her slightly upright hand, albeit not in defence, as one might think at first sight, but rather in a gesture of greeting. Such a gesture may also be observed on the part of the angel of the Annunciation, and in identical fashion with Venus in *Primavera* (Illus. p.40) and Wisdom in the fresco of the seven Liberal Arts receiving Lorenzo Tornabuoni (Illus. p.55).

The hands of the angel and Mary constitute the central point of the painting (Illus. p.65). Mary's left hand is reaching out towards the right hand of the angel, while the latter remains as if at an unbridgeable distance. The fascination of this interaction between the two hands lies in the very fact of their striving to touch each other but being held back as if under a magic spell. However, their great attractive force can be attributed to the fact that the localization of the hands in the picture is in accordance with the rules of the Golden Section, the division of lines and areas according to certain ratios, which had been common knowledge since antiquity and was regarded as particularly harmonious. The positions of the hands function in a fascinating manner as the linking agent between the two halves of the picture, which are strictly divided by the vertical lines of the doorway. Mary's slightly lowered hand encounters the horizontal line of composition which predominates in the angel, while the angel's raised hand underlines Mary's standing pose. At the same time, the angel's hand epitomizes the unbridgeable distance between the two parts of the picture, each of which is the realm of one of the figures: his hand is located precisely at the edge

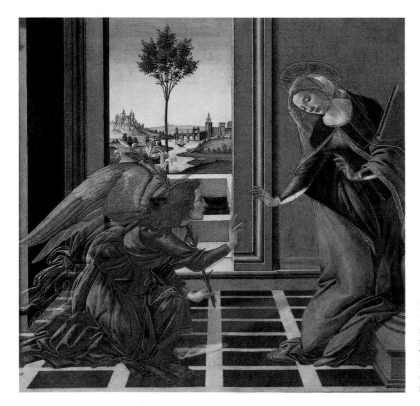

The Annunciation, c. 1489/90
Botticelli painted this picture for Ser Francesco Guardi, a man from a simpler background than the painter's other clients of the 1480s. The altarpiece was intended for Guardi's family chapel, its purpose not only his spiritual salvation but also – assuredly – the enhancement of his social prestige.

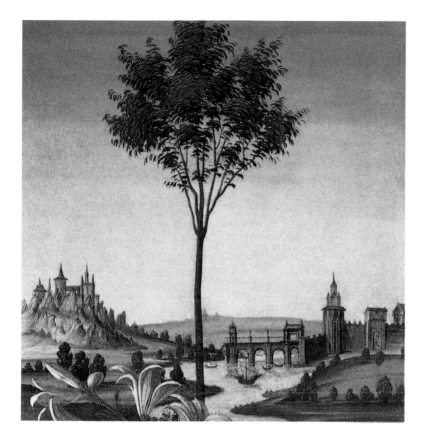

The Annunciation (details, cf. p. 64)
The architectural motifs of the landscape with river which spreads out in the background reveal northern features. A multi-towered, mediaeval castle rises on a bizarrely shaped mountain to the left.

The hands of the angel and Mary constitute the central point of the painting. Annunciation and acceptance of the message are expressed in a fascinating manner here.

of the door jamb, the vertical line of which delineates a clear distinction between Mary and the angel. This division of the two halves of the picture is emphasized by their differing layouts. Thus it is that a broad landscape opens out behind the angel, whereas Mary for her part remains surrounded by walls, symbolizing her purity. This connection between exterior and interior, on the one hand, and the location in the picture of the angel and Mary respectively, on the other, is in accordance with a tradition known to have been in existence since the Middle Ages, and may also be found in Botticelli's earlier portrayals of the Annunciation (Illus. p. 30).

Theological writings of the 15th century divided the Annunciation into different, successive mental states, representative of the different reactions on the part of the Virgin to the heavenly message. These began with the *conturbatio* of Mary, her agitation, followed by the Virgin's reflection, her enquiry, and her submission. In their pictures of the Annunciation, the painters of this period revealed themselves to be influenced by this analysis, as is visible in Botticelli's apparent recording in his pictorial composition of the first stage, Mary's agitation. The portrayal of an agitated Mary did not appeal to every painter, however; Leonardo, for example, commented admonishingly: "... a few days ago I saw the picture of an angel, who, while performing the Annunciation, appeared to be driving Mary out of her room with movements which looked like an attack such as could be conducted against a hated enemy; and Mary seemed to be trying to throw herself out of the window in desperation. Do not fall into such misconceptions."

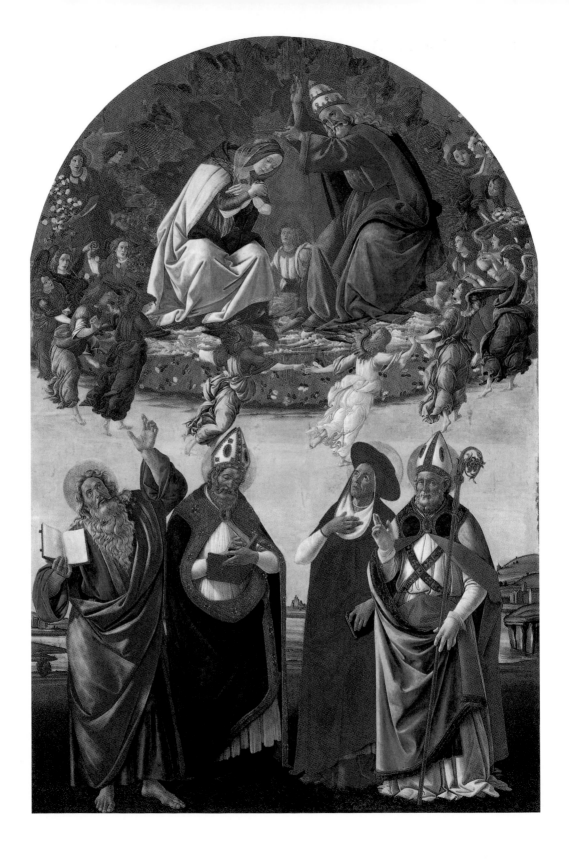

Piety and Asceticism

The beginning of Botticelli's late period of creativity is marked by the painting *The Coronation of the Virgin with Four Saints*, which the artist executed sometime around 1490 (Illus. p.66). Five hundred years later, in 1990, the picture aroused considerable public attention when it was displayed in an exhibition in Florence intended to document the manner in which it had been rescued from ultimate disintegration. Twenty years previously, on 28th July, 1969, the painting had been transported to the restoration studios of Fortezza da Basso in Florence. It was essential to carry it horizontally, since the paint was threatening to come away from the wooden surface. Almost nothing could be seen of the work itself any longer, since it was covered with strips of Japanese woodcut paper as a rough-and-ready means of preventing the paint from becoming completely detached from the wood. Yet what had led to the picture's being so badly damaged? The reasons may be found mainly with Botticelli himself. The painter had left away the usual ground, presumably as a result of a wish to experiment, applying the paint directly onto the wooden surface of the panel. At the same time, he had employed an unusual amount of oil when preparing his paints, resulting in their drying too quickly and therefore failing to penetrate into the wood. These two factors had caused the paint to come away from the wooden surface. In the course of twenty years of restoration work, the particles of paint were attached to the surface again; areas where paint was missing were repaired. Since its restoration, this work, which previously had been little appreciated on account of its poor state of preservation, has undergone a new and revised assessment, one justly deserved; it may be considered today to number among the principal works from Botticelli's late period.

In the upper section of the picture, we see God the Father in front of a gold ground. He is in the process of placing the crown with His left hand on the head of the Virgin, who is bowing down before Him; with His right hand, He is giving her His blessing. Cherubim and Seraphim form a glory in blue, red and gold above the two figures, corresponding to the roundelay of hovering angels below. Botticelli has conveyed the idea of the spatial depth of their dance in a fascinating manner, placing the angel appearing in the background between Mary and God the Father behind the golden rays. St John the Evangelist, St Augustine, St Jerome and St Eligius are standing in the lower section of the picture, their different postures lending expression to their reactions to the event. The emotional involvement on the part of each of the figures in the picture is striking; its intensity sets it apart from Botticelli's earlier depictions and heralds an important characteristic of the artist's late work. Compare, for example, the vehement gesture of blessing of God the Father, the emotion of St John the Evangelist, pointing to the occurrence with broad gesticulations, or St Jerome, so deeply affected as to be unaware of anything else happening around him. Even the angels are gripped

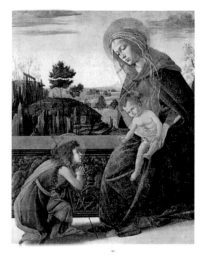

The Virgin and Child with the Young St John the Baptist, c. 1493

The Coronation of the Virgin with Four Saints: St John the Evangelist, St Augustine, St Jerome and St Eligius, c. 1490
This painting was commissioned by the Guild of Goldsmiths, which explains the generous employment of expensive gold: it was of course unthinkable that the goldsmiths be sparing with this material.

67

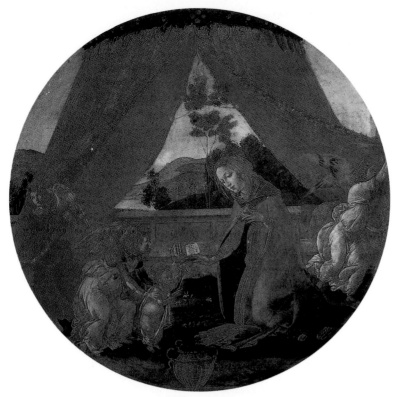

The Virgin and Child with Three Angels (The Madonna del Padiglione or Ambrosiana Tondo), c. 1493

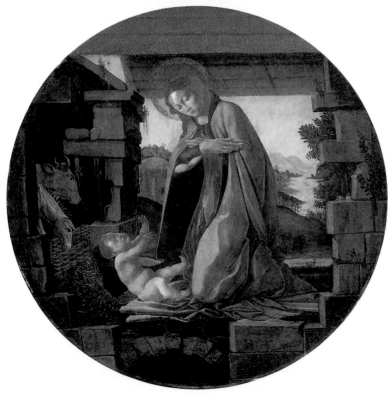

The Virgin Adoring the Child, c. 1490

by a whirling momentum, as revealed by their vigorously billowing garments and flowing hair.

The apparently mediaeval gold ground in the upper part of the picture may be attributed to the persons commissioning the work, the Guild of Goldsmiths, who had ordered it for the chapel of their patron saint in San Marco. It was doubtless their intention that the lavish use of gold should draw attention to their profession. Seen from this perspective, the presence of St Eligius, who is otherwise depicted only rarely, and the addition of St John the Evangelist becomes easy to understand: the former was the patron saint of goldsmiths, the latter the patron saint of the Arte della Seta, the Guild of Silk Merchants, under which various craftsmen's guilds, including that of the goldsmiths, were subsumed.

A number of mostly round pictures of the Virgin follow the *Coronation of the Virgin*, Botticelli portraying in them the Virgin herself with the Christ Child and angels. Here too the stylistic change undergone by the artist's work and marking the beginning of his late output becomes visible. However, it is expressed here less in the intensity of emotion felt by the figures in the picture than in Botticelli's turning away from the harmonious proportions of his figures in relation to the space enclosed by the picture. In all four paintings illustrated here, for example, the figure of Mary seems disproportionally large. This is particularly striking in the panel from Chicago (Illus. p. 69) and in that from a private Japanese collection (Illus. p. 67); in the *Ambrosiana Tondo* (Illus. p. 68, top), this is the case only with Mary's head, which seems too large when compared with the rest of her body. In adopting such a manner of depiction, Botticelli was turning away from the well-balanced Renaissance ideal with regard to the portrayal of bodies and going back to the mediaeval importance/size formula, according to which the degree of importance attached to individuals appearing in a painting was directly reflected in their relative size in the picture. Botticelli was thus giving priority to the message of the picture over the correctly proportioned and aesthetically pleasing appearance of the figures.

What had prompted the artist to reject the achievements of the Renaissance and concentrate upon the message of his pictures? Botticelli was reacting to the wave of a new religious feeling which had been growing more and more in influence since the end of the 1480s and was characterized by deep involvement and passionate emotion. The protagonist in Florence of this inner changing of one's ways was Girolamo Savonarola, a Dominican monk, who appealed to the citizens of Florence in his sermons calling for repentance to set themselves free from their sinful and dissipated lives. Savonarola particularly denounced the luxurious way of life pursued by the Medici family. Like the majority of his contemporaries, Botticelli – one of the most distinguished Medici artists and the painter of the most important mythological pictures for them – was deeply affected by Savonarola's rousing words. This may be observed not only in the stylistic change visible in his work from the 1490s onwards but also in the drastic reduction in the proportion of secular subjects painted. Six large paintings with secular content from the 1480s have come down to us, the conception of their figures typically betraying the strong influence exerted upon the artist by antiquity; in contrast, only one single work of this kind is known from his late output. All of the other pictures are concerned with religious subjects. The greatest effect of Savonarola's world view upon Botticelli would become especially visible towards the end of the century; it will be examined at greater length in the following chapter.

For the present, however, let us return to the *Madonna del Padiglione* or *Ambrosiana Tondo* (Illus. p. 68, top), which is distinguished from the other pictures of the Virgin illustrated here through its detailed refinement and exceptional

The Virgin and Child with Two Angels, c. 1493
Botticelli painted a considerable number of pictures of the Virgin at the beginning of the 1490s. These reveal a stylistic change, one heralding the artist's late work. Botticelli was turning away from the harmonious proportions of his figures, with the result that Mary appears excessively large in the paintings illustrated here.

elegance. A further name given the work, that of the *Baldachin Madonna*, stems from the red, baldachin-like tent being pulled aside by the angels in order that the devout may participate in the divine scene. The tondo may perhaps be identified with the one seen by Botticelli's earliest biographer, Giorgio Vasari, in the chamber of the Prior of the Camaldolese monastery of Santa Maria degli Angeli in Florence at the beginning of the 16th century. This monastery stood under the special protection of the Medici. Lorenzo the Magnificent had appointed Don Guido Prior in 1486; he was one of Lorenzo's closest confidants and would receive his deathbed confession in 1492. The monastery developed under Don Guido's leadership into a centre of humanistic studies, until the monks rebelled under Savonarola's influence against their seemingly all-too-worldly prior and

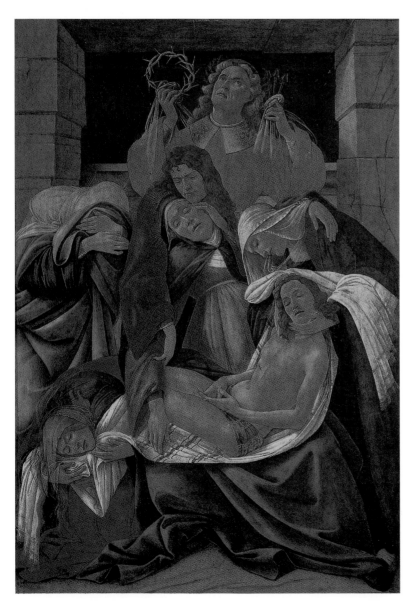

Lamentation over the Dead Christ, c. 1495
Botticelli was reacting in the pictures of his late output to the new religious sensibility in Florence triggered by the famous sermons of Girolamo Savonarola, a Dominican monk, calling for repentance.

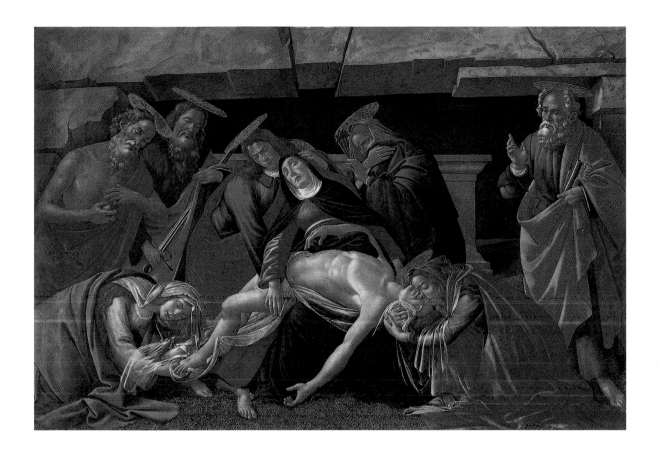

expelled him from the city. The close ties linking Prior Don Guido with Lorenzo
the Magnificent appear to have found their illustration in the painting: the tent
of the *Madonna del Padiglione* is adorned at its uppermost end with laurel
twigs, in the dark green foliage of which red fruits glow, a depiction reminiscent
of the garden in *Primavera* (Illus. p. 40). In the latter painting, the laurel bran-
ches and the fruit (interpreted as oranges) constituted a reference to the Medici;
perhaps the same is true here.

The stylistic changes touched upon above are especially striking in two paint-
ings of the *Lamentation over the Dead Christ* (Illus. pp. 70, 71), the Milan por-
trayal, painted somewhere around 1495 (Illus. p. 70), conveying the intense grief
of the mourners in a particularly vivid way. In order to heighten the emotional
impact on the observer, Botticelli placed the figures directly adjacent to the
edge of the picture, abandoning any effect of distance. The gaze of the observer,
who is thus invited to participate in the picture, falls first upon the body of the
dead Christ, which, together with the white linen cloth, stands out wanly against
the black robe of the Virgin. His gaze is then led upwards through the steep dis-
position of the figures drawn up one behind the other, over the cruciform ar-
rangement, to reach its high point in the gaze of Joseph of Arimathea, looking
up to heaven with a questioning, grief-stricken expression on his face. Further-
more, Botticelli has conveyed the idea of the close relationship between the
apostle John and the Virgin in a particularly vivid manner. In the same way that
both stood as one under the cross until Christ's death, so they appear here, fused
together in a similar posture with the one lying against the other to form a unity.

Attention should also be paid to the figure of Mary Magdalene on the left-hand side of the picture, bending down over Christ's feet so as to caress them in an infinitely tender gesture. The totality of the painting's composition conveys the fervent religious zeal of Savonarola's followers; it is hardly surprising to learn that two members of the family of Donato Cioni, who had commissioned the painting, were in fact *piagnoni*, or "weepers", as Savonarola's comrades-in-arms called themselves.

The last painting in which Botticelli was to take a secular story as his subject is *The Calumny of Apelles* (Illus. p.72). The observer is surprised both by its relatively small size – a mere 62 x 91 cm – and by the miniature-like fine painting technique. These two factors lead to the assumption that this picture – like the panels of twenty years before depicting the story of Judith – was intended not as a wall decoration or as an ornamentation for a piece of furniture but rather as a particularly precious and treasured object, inviting the observer to examine it closely. The portrayal recreates a lost picture by Apelles, the famous classical painter, known to us solely through its description by the poet Lucian in his "Dialogues".

Lucian tells us that the painter Antiphilos, driven by envy of his far more talented colleague Apelles, accused him of being involved in a conspiracy against the Egyptian king Ptolemy IV, at whose court both artists were engaged. The innocent Apelles was thrown into prison, until one of the real conspirators testified to his innocence. Ptolemy rehabilitated the painter by giving him Antiphilos as his slave. Apelles, still filled with horror at the injustice that had been done him, painted the afore-mentioned picture, in which the calumny against him was presented in allegorical manner, as may be seen in similar form in Botticelli's painting.

The king is sitting on the right-hand side of the picture on a raised throne in an open hall decorated with reliefs and sculptures. He is flanked by the allegorical figures of Ignorance and Suspicion, who are eagerly whispering the rumours in his donkey's ears, the latter to be understood as symbolizing his rash and foolish nature. His eyes are lowered, so that he is unable to see what is happening; he is stretching out his hand searchingly towards Rancour, who is standing before him. This latter, clothed in black, has fixed the King with a piercing look

ILLUSTRATION TOP AND DETAIL PAGE 73:
The Calumny of Apelles, c. 1495
This is the last painting to take a secular story as its subject-matter, Botticelli hereafter painting only religious works. Here he takes as his central theme the allegorical treatment of the calumny of an innocent man.

St Augustine Writing in his Cell, c. 1490–94

Portrait of a Man (Michele Marullo Tarcagniota?), c. 1490–95

Portrait of Lorenzo di Ser Piero Lorenzi, c. 1495–1500

Portrait of a Young Man, c. 1485/90

Portrait of a Young Man, c. 1489/90
The subjects of these portraits were important figures from Florentine life. Lorenzo di Ser Piero Lorenzi was Professor of Philosophy and Medicine in Pisa, whose reputation reached its height at the end of the 15th century. His death was less distinguished, however: he threw himself into a well out of despair at being unable to raise the money for the purchase price of a house in Florence.

and is stretching out his arm with its overlong hand towards him in a sharp, aggressive gesture. With his right hand he is dragging Calumny forward; as a symbol of the lies which she has spread, she is holding a burning torch in her left hand, while she is pulling her victim, an almost naked youth, by the hair behind her with her right hand. His innocence is shown by his nakedness, signifying that he has nothing to hide. In vain has he folded his hands so as to beseech his deliverance. Behind Calumny, the figures of Fraud and Perfidy are studiously engaged in hypocritically braiding the hair of their mistress with a white ribbon and strewing roses over her head and shoulders. In the deceitful forms of beautiful young women, they are making insidious use of the symbols of purity and innocence to adorn the lies of Calumny. At some distance follows Remorse, an old woman dressed in a torn black gown; her mouth twisted with bitterness, she is turning to look at the final figure, Truth, standing at the edge of the picture. This latter appears like the statue of a classical goddess, reminiscent of Botticelli's *The Birth of Venus* (Illus. p.51). A naked woman whose beauty is quite perfect, she is pointing upwards with the index finger of her left hand in the direction of those powers from whom the Last Judgement regarding truth and falsehood can be expected. She is paying no attention to the doings of the others, who are all making for the king, and is thereby completely isolated from them; as such, she is manifesting her incorruptibility and immutability. Her nakedness links her with the blameless youth, while the other figures have hidden their true nature under their clothing. Rancour and Remorse frame Calumny and her comrades, representing the cause and consequence of the betrayal. Botticelli has made it clear that they belong together through their black garments, which set them apart from the bright clothing of the other figures.

Several generations of art historians have occupied themselves with the question as to why and for whom Botticelli should have done this painting. In the absence of a definite answer, we are left with nothing better than conjectures. The question is equally open as to whether the picture contained a personal reference for Botticelli. Might it have served as a hidden allusion to one of his patrons, who had shown a preference for another artist? Or had Botticelli – like Apelles – become involved in all innocence in some intrigue or other, and was seeking to draw attention to it through his picture? We know, for example, that he was indeed accused secretly in 1502 of having had homo-erotic relations with his pupils. Or was the picture painted before Botticelli's religious conversion through Savonarola, as some suppose? If so, could the artist have been defending himself here against the slander campaigns of the preacher, who passionately condemned unbelievers and spendthrifts – indeed, all those addicted to a sensuous existence, and thus also artists, who portrayed this sensuality in their paintings?

While we have no answers to these questions, the painting nonetheless attests to the tense situation in Florence at this time, with the end of the century approaching. It was an era of great religious unrest, manifested in a fear of the expected apocalypse and resulting in an increased mistrust of one another.

Attention should be drawn in conclusion to Botticelli's late portraits, which similarly reveal the stylistic changes in his work (Illus. p.75). Now he no longer added landscape vistas or the view of inner rooms, as he had done in his earlier portraits. Instead he reduced the background to a surface of one colour alone, in order that the observer's attention not be distracted from the depicted person. This reductive manner of painting, sometimes almost ascetic in its effect, reflects Botticelli's breaking away from the sumptuously ornamented, decorative style in which he had previously treated his pictorial subjects, a development which was to become even more marked in his final works.

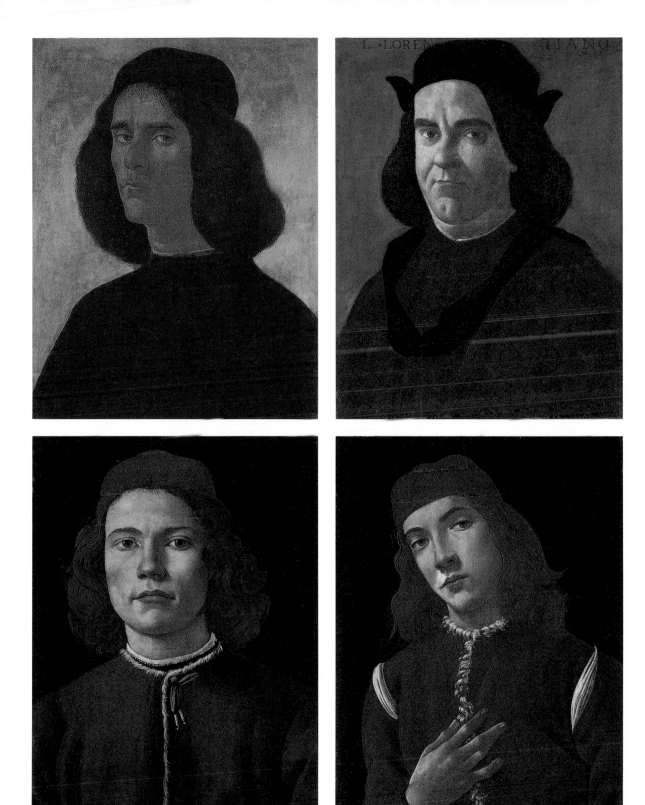

Inferno, Canto XVIII, 1480–90
We see Dante with Virgil, his guide, in the eighth circle, which consists of ten deep chasms in which those guilty of fraud are punished.

Inferno, Canto XXXI, The Giants
(detail), 1480–90
This sheet depicts the giants of antiquity, who had risen up against the gods and were placed in chains. They represent the raw power of nature.

Inferno, Canto XXXIV, Lucifer
(detail), 1480–90
This detail from the thirty-fourth and final Canto depicts three-headed Lucifer, engaged in crushing the three greatest sinners of mankind, namely Brutus and Cassius – Caesar's murderers – as well as Judas, who betrayed Christ.

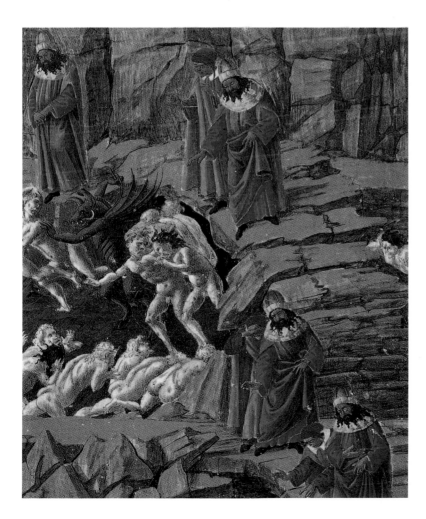

Botticelli and Dante

Botticelli often concerned himself during his lifetime with illustrations for Dante's "Divine Comedy". He executed the drawings from the cycle illustrated here over a relatively long period of time, from about 1480 to 1500. The identification of these illustrations with the Dante cycle which Botticelli is known to have done for Lorenzo di Pierfrancesco, his great patron from the Medici family, seems not improbable.

For some reason unknown to us, the drawings were never completed. Only four of the surviving 93 sheets – nine having been lost in the course of time – are coloured, although this was presumably the original intention for all of them.

TOP LEFT:
Paradise, Canto VI, 1495–1500

TOP RIGHT:
Portrait of Dante, c. 1495

LEFT:
Inferno, Canto XVIII (detail), 1480–90

An Apocalyptic Mood

It had always been the case that the final years at the end of a century were filled with apocalyptic visions and premonitions of the approaching last days of the world, and the same was true of Florence. The closer the end of the 15th century drew, the more widespread the fear of the imminent end of the world and the coming of the Last Judgement became. This was announced in fiery speeches by Girolamo Savonarola, the Dominican monk who – as mentioned in the previous chapter – was urging the inhabitants of Florence to repent and do penance for their shameful and all-too-worldly lives. The Dominican's campaign was directed in the first place against the luxurious way of life pursued by the populace. He accordingly erected a so-called "bonfire of the vanities" on 7th February, 1497, on the Piazza della Signoria, the location of the seat of government, bidding the citizens of Florence to burn their splendid garments, valuable furniture, books, paintings, and other luxury items. We know that artists were also among those on the Piazza, delivering their own drawings and paintings up to the flames. Evidence exists, for example, that Lorenzo di Credi, a former companion of Botticelli's, destroyed several of his nude studies, which now struck him as indecent. It is maintained that Botticelli too, swept along by the general current of emotion, burnt some of his own pictures; however, the evidence for this is no more than circumstantial.

At the same time, however, this religious zeal – which was to develop increasingly into religious fanaticism – was accompanied by political unrest. The year 1492 saw the death of Lorenzo the Magnificent, himself not uninfluenced by the preaching of Savonarola. The political succession fell to his son Piero, who lacked not only the diplomatic skill but also the statesmanlike experience of his father. He soon came into conflict with the French crown and dissolved the traditional alliance with France – a particularly rash move, since it decisively hampered the business interests of the Florentine merchants and thus provoked their opposition to the Medici. Revolt against the all-too-despotic rule of the family was also growing among the people, and on 9th November, 1494, after Piero had been forced to capitulate to King Charles VIII of France, the Medici were driven out of Florence. Their coat of arms was taken down from all the palaces, to be replaced by that of the people, a red cross on a white background. Savonarola was also a participant in the consultations concerning the change of government, his position of power solidly established through his great influence over the people. Before looking at this political development in greater depth, however, we should first turn to Botticelli's picture *Mystical Crucifixion* (Illus. p. 80), which portrays these events in an impressive manner.

Now regrettably severely damaged, the picture depicts Christ on the cross in the foreground against a white field. The penitent Mary Magdalene is clinging

The Mystical Nativity (detail)

The Mystical Nativity, c. 1500
The closer the end of the 15th century approached, the more people were filled with the dread of the expected end of the world. Nor was Botticelli free of such a sentiment. His painting bears witness to his hope that the Powers of Heaven would overcome the Devil (see the above detail).

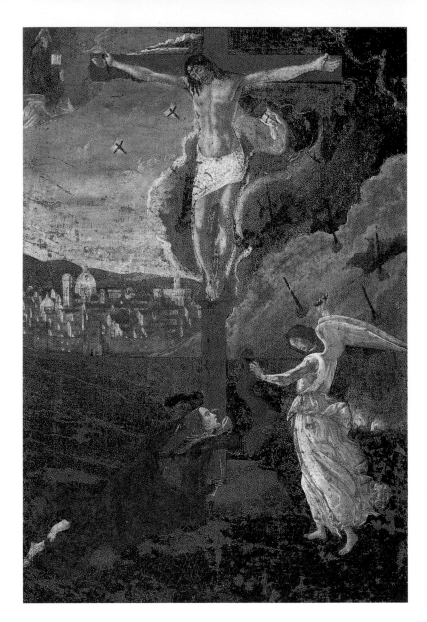

to the base of the cross in a passionate, almost wild gesture. Below her red gown, a creature is running away to the left; while the poor condition of the picture no longer allows us to identify it with certainty, it could be interpreted as a fox or a wolf. An angel clothed in white is standing on the opposite side, striking a young lion dead with his sword. The city of Florence may be seen in the background, spread out in bright light under a clear sky. Within the city walls, the dome of the Cathedral, the Campanile, the Baptistery and the Palazzo Vecchio – the seat of government – to name but a few buildings, are readily recognizable. A dark black cloud has just moved to the right-hand side of the picture; it is filled with devilish beings hurling flames down upon the earth. At the behest of God the Father, hovering in a glory in the top-left cor-

The Agony in the Garden (Christ on the Mount of Olives), c. 1500
This is the only one of Botticelli's paintings known to have been exported from Italy during the artist's lifetime. It is recorded as being in the possession of Isabella the Catholic, Queen of Castille, in 1504. It was probably brought to the court of Castille by a merchant, accompanied by various other luxury goods.

ner of the picture, this cloud has been driven away by angels; they are as good as invisible today, and only their shields, bearing a red cross on a white field, can be discerned.

Not until this picture is seen against the background of the religious and political changes in Florence at the time of Savonarola can it be understood. The form of Mary Magdalene personifies the city of Florence, which, its conscience stirred by Savonarola, is repenting of its sins. The fox or wolf escaping from the gown of the penitent, and the lion which the angel is dispatching, are ancient symbols of deceit and violence, leaving penitent Florence or being done away with. Simultaneously, God the Father is driving away the hellish clouds hanging over the city. The shields of His heavenly host are decorated with the coat of

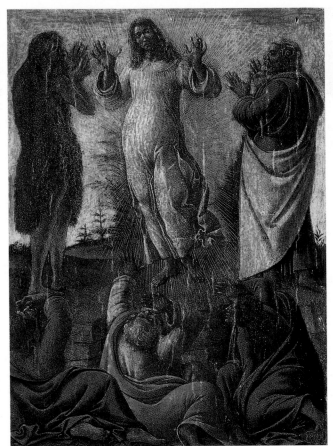
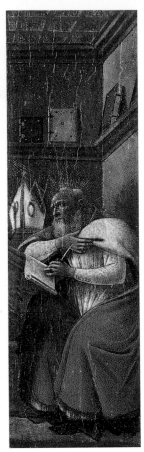

The Transfiguration, St Jerome, St Augustine, c. 1500
Here, too, Botticelli was paying less attention to correctness in perspective, intent rather upon focussing the observer's concentration on the figure of Christ.

arms of the people. The picture thus represents the time after the end of Medici rule, one in which peace and justice have returned to Florence.

The painting's political and religious message finds its parallel in its stylistic form. As in the paintings from the 1490s examined above, the proportions of the figures in this picture appear overlong, their reactions marked by passionate emotion. We are also struck by Botticelli's renunciation of the lavish wealth and extensive brightness of his earlier works. His figures are clad now in simple, single-colour garments, and darker shades of colour predominate, determining the atmosphere of the painting.

Such stylistic characteristics may be observed in Botticelli's other paintings from this period, among them *The Last Communion of St Jerome* (Illus. p. 83), which Botticelli may have done around 1495. The subject of the work is the moment in which St Jerome receives the sacred Host from the hands of his companion, St Eusebius, for the last time before the former's death. The scene takes place in a simple thatched hut, its lack of ornamentation intended to underline the modest lifestyle of the hermit. The room is open to the front, allowing the faithful to participate directly in the action.

Brown and white hues predominate in the picture, to be seen in the garments of the acolytes holding the candlesticks, in the clothing of St Jerome himself and the monks standing behind him, and in the blanket spread out over the

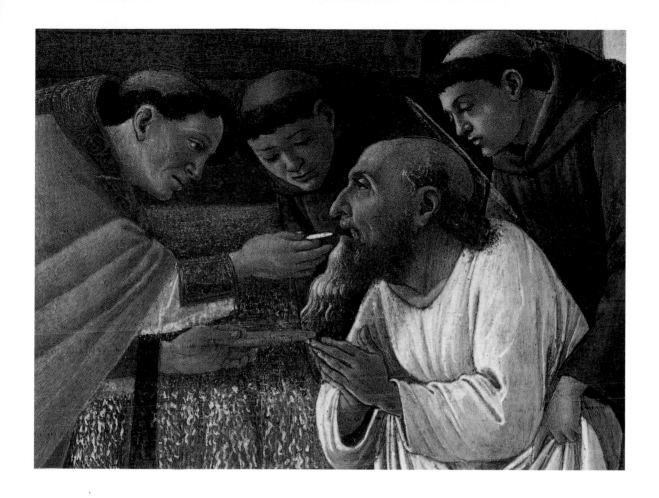

ILLUSTRATION BOTTOM AND DETAIL TOP:
The Last Communion of St Jerome, c. 1495

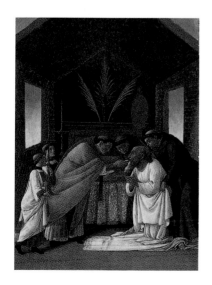

saint's bed. The bright red cloak of St Eusebius and St Jerome's brilliant-red cardinal's hat, hanging on the wall, as well as the bright blue hues of the sky, stand out against the browns and whites, generally imbuing the painting with a restrained colourfulness. Unlike the early pictures, the simple garments no longer reveal a swaying contour, nor do they fall any longer in imaginatively moving folds; instead, they are distinguished by an emphatically simple draping. In a manner similar to that used in his *Madonna del Padiglione* (Illus. p. 68), Botticelli has marked the principal figure of this picture, St Jerome, by giving him an overlarge head.

The stylistic change undergone by Botticelli's art is demonstrated especially vividly through a comparison of his *Judith Leaving the Tent of Holofernes* (Illus. p. 86), from the late 1490s, with the work of similar subject from some thirty years previously (Illus. p. 17). In the earlier work, the picture was dominated by movement and lively gracefulness; now, concentrated pictorial composition and simplicity come to the fore. With the former picture, the observer's thoughts were distracted by the detailed presentation of the figures and the background; in the later version, Botticelli has left out everything that could divert attention from the principal figure, from Judith herself. Thus, Abra the maid no longer appears next to Judith, but is relegated to the dark opening of the tent in the background. At the same time, Botticelli has reduced everything of a dec-

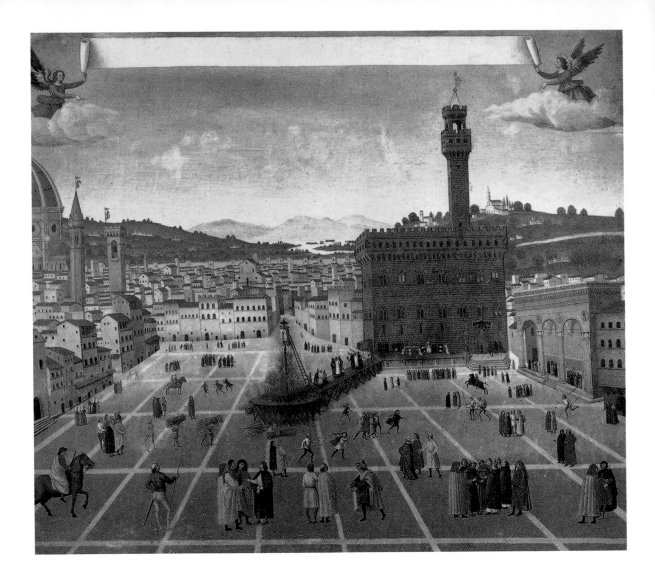

Anonymous:
***The Execution of Savonarola on the Piazza della Signoria**, 1498*
Savonarola's activities, which were increasingly taking on the appearance of fanaticism, caused more and more people to oppose the preacher. Finally, in 1498, he was imprisoned, found guilty of heresy, and publicly strangled and burnt at the stake.

orative nature to a minimum. Background and earth appear merely as a monotone surface, while the dark, unadorned garments remind one that the elegant flow of folds found in the bright, richly ornamented dress of the earlier portrayals is absent here. In this work too, the form of Judith herself strikes us as having overlong proportions, such as strangely distort her and present a crass contrast to the gracefulness of the earlier Judith. Botticelli was evidently less concerned in this late phase with entertaining the observer, concentrating rather on a form of his pictorial subject matter which would edify and instruct.

The fate of Savonarola, preaching in Florence, was to change shortly after the mid–1490s. His fanatical behaviour, bordering on tyranny, unleashed ever more radical opposition against him, not only spreading amongst the city's inhabitants and the members of the Florentine government but even reaching the Curia in Rome. The Holy See replied to Savonarola's uncompromising criticism of the official Church with his excommunication in May, 1497. The preacher's precarious position was to deteriorate still further. Savonarola was imprisoned, and

Fra Bartolommeo:
Girolamo Savonarola (1452–1498), c. 1497
The Dominican monk exerted an extraordinarily great influence upon his contemporaries through his passionate sermons calling for repentance, an influence that was virtually irresistible to most.

with the support of Pope Alexander VI was accused of heresy and sentenced to death by strangulation and burning at the stake. On 23rd May, 1498, the preacher was publicly executed on the Piazza della Signoria and his body given over to the flames, as recorded by an anonymous artist in a contemporary painting (Illus. p. 84). A porphyry slab later set into the ground today marks the spot where Savonarola was burnt at the stake.

Botticelli showed himself deeply affected by these events, for his own brother Simone was an ardent supporter of Savonarola, a *piagnone*. Simone was forced to flee to Bologna on account of the persecution and punishment of the *piagnoni* that followed the execution of the preacher. We can read in the diaries that Simone kept at the time how shaken Botticelli was by the sentence carried out by the government against Savonarola. In a private meeting with one of the committee members, he dared to ask why they had made Savonarola die such a shameful death. However, the paintings which Botticelli executed after these events tell us even more than these notes. Foremost among these is *The Mysti-*

cal Nativity (Illus. p. 78); it should also be numbered among the most important works of his late period. At first glance, it would appear to be a simple representation of Mary and the shepherds. The middle of the picture is occupied by a rock cave, its rear opening revealing a meadow on which the early morning light is falling. Framed by the arch-like rocky entrance, Mary and Joseph are situated in front of the cave under a thatch roof supported by two bare tree trunks. Shepherds wearing wreaths are kneeling to each side of them, their attention drawn by angels to what is happening. The principal figure in the picture is Mary, to whose form the observer's gaze is initially led. Not only is she the largest figure in the painting; she is also located exactly in the middle. If the inscription at the top of the painting is removed, then her left eye is situated at the very mid-point of the work. Above the scene of the Adoration, the blue sky opens up into a golden glory, in which angels are dancing a roundelay. Their rhythmically harmonious circling is reinforced by the alternating colourful triad of their brown, white and reddish-orange garments. The angels bear olive branches in their hands, to which crowns and banderoles are attached, pronouncing the praise of Mary.

On examining the lower part of the painting more closely, however, we notice that it departs from a conventional representation of the Adoration. We observe three pairs of angels and mortals happily embracing each other on the foremost stretch of grass, with several devils lying on the ground, bound to poles (Illus. p. 79). The people here are also holding olive branches with banderoles, the texts of which are taken this time from the Gospel according to St Luke: "On earth peace to men of goodwill".

The key to understanding this picture may be found in the Greek inscription concluding the work at its uppermost edge:

"This picture I, Alessandro, painted at the end of the year 1500, in the troubles of Italy, in the half-time after the time, during the fulfilment of the eleventh of John, in the second woe of the Apocalypse, when the Devil was loosed for three and a half years. Afterwards he shall be chained according to the twelfth and we shall see him [trodden down] as in this picture."

The painting conveys the idea of the arrival of the time of peace which will follow the woes described by St John in his Revelation. Botticelli saw himself as living in the period of the second woe in the eleventh chapter of the Apocalypse, where the evangelist narrates how the court of the Temple is abandoned to the heathen for 42 months (or three and a half years). After this, the prophecy described by St John in the twelfth chapter will be realized: the woman of the apocalypse appears, who, fleeing from the Devil, will give birth to a child. Exegetical writings had long identified the woman of the apocalypse with Mary, while simultaneously interpreting her as symbolizing the Church. And this is also the subject of Botticelli's representation: Mary should be understood here as symbolizing the Church, explaining her pointedly central position in the painting. With the birth of its Redeemer, the Church will be led to its renewal. A new day will break, as heralded by the morning light in the background of the picture, glimmering through the trees in the wood. The Devil will be banished for ever, and everlasting peace will reign, as proclaimed by the olive branches and the messages of peace on the banderoles. Botticelli did not see this *renovatio* as happening at some distant point in time; Savonarola had similarly prophesied that it would soon come to pass. Indeed, according to Botticelli's calculations, it was to occur as soon as 1503.

The artist's final works are distinguished by their dramatic expressivness and the restless, broken rhythm of the compositions. Attention should be drawn here

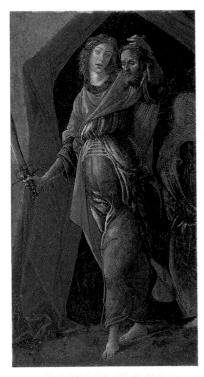

Judith Leaving the Tent of Holofernes, c. 1495–1500
In contrast to his earlier paintings, Botticelli later portrayed things in as unadorned a fashion as possible. Here, for example, the plain garments no longer fall in an elegant arrangement of the folds.

86

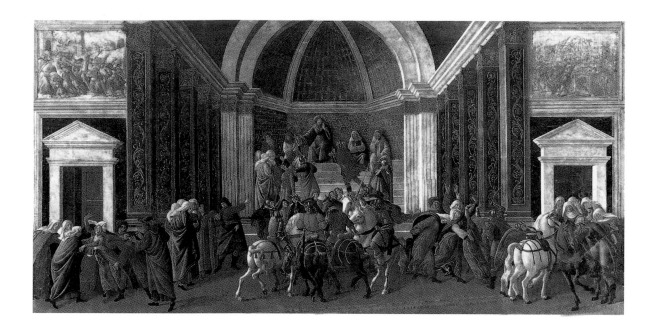

The History of Virginia, c. 1504
In Virginia and Lucretia (cf. Illus. p. 89), Botticelli was taking up two heroines from Roman antiquity whose virtuousness served as a model for Christians. Both paintings take the condemnation of despotic rule and the revolt of the people as their subject.

The History of Virginia (detail)

in particular to two panels which narrate the *Histories of Virginia and Lucretia*, two heroines from the Roman era whose virtuousness served as a Christian model (Illus. pp. 87, 88, 89). The unity of content is clearly revealed by the division of each of the panels into three parts, the settings of which are distinguished by forms from classical architecture. Botticelli was portraying several scenes simultaneously in both pictures, thus falling back on the mediaeval style of simultaneous depiction.

In the panel concerned with Virginia (Illus. p. 87), the events are taking place in a great hall bounded by richly decorated columns. Appius Claudius, one of the *decemviris*, the ten men who exercised power in Rome, is enthroned in the raised apse, which is covered by a semidome. Appius Claudius desired the previously betrothed Virginia as his wife, and had her abducted by force. We can see Virginia on the left-hand side of the picture, being apprehended by the servants of the ruler and taken to him. In the succeeding scene, which takes place in the background, her father, recognizable by his red cloak and helmet, is pleading for mercy. Appius Claudius refuses to grant his request, however, and the father leaves, weeping. The story continues on the right-hand side, where the father, in order to save the honour of his daughter, kills her and then calls upon the Roman army to mutiny against the tyrannical commanders. The final incident constitutes the central point of the picture, where Roman soldiers have banded together on their horses.

The panel involving Lucretia (Illus. p. 89) takes a very similar incident as its subject; here, too, the story should be read from left to right, ending in the middle. The son of the cruel Roman king Tarquinius desired Lucretia, who was married to Brutus, and took her by force. We see him on the left-hand side, threatening the young woman with a dagger and ripping her red cloak from her body. Lucretia takes her life because of the dishonour done to her, stabbing herself with a dagger. We can follow this on the right-hand side of the picture, where she is falling lifeless into the arms of her husband, who is accompanied by some soldiers (Illus. p. 88). Both scenes flank the event in the centre of the

picture, which is taking place in front of a splendid triumphal arch: Brutus is calling for revenge for the death of his wife, who is laid out before him, and for a struggle for liberation against the tyrannical king.

Both paintings depict as their principal event a revolt by the citizens of Rome and its soldiers which has been brought about by the despotic behaviour of the city's rulers. In the case of Lucretia, this rebellion led to the abolition of the monarchy and the establishment of the republic in Rome, while the republic was re-established following the death of Virginia through the ensuing deprivation of the power of the decemvirs. If we place the obvious republican inclinations of the person commissioning Botticelli's two paintings within the context of historical events in Florence, then it would seem that both pictures allude to the ousting of the Medici family and the ensuing establishment of the Florentine republic. Further pictorial elements indeed confirm this interpretation, such as the statue of David so conspicuously placed on the porphyry column in the Lucretia panel, and the relief on the left-hand side of the picture over the portal showing Judith with the head of Holofernes. In depicting Judith, Botticelli was falling back on his panel painted some thirty years before of *The Return of Judith to Bethulia* (Illus. p. 17, top). The idea of decorating a city square with representa-

The History of Lucretia (detail)

88

tions of David and Judith may be attributed without doubt to the political situation in Florence. When the Medici family were driven out of the city in 1494, their bronze sculptures of David and Judith, executed by Donatello, were taken from them. The statue of Judith was placed conspicuously on the left-hand side of the main portal to the Palazzo Vecchio, while that of David was erected in the inner courtyard of the Palace. Both sculptures served the young Republic as symbols of tyranny overcome. In the same way as Judith and David had vanquished their more powerful enemies through cleverness and courage, so had the Florentine people succeeded in freeing themselves from the tyrannical rule of the Medici family. The following inscription was accordingly placed on the plinth of the statue of Judith: "Erected by the citizens as an example of public deliverance 1495."

In contrast to the deployment of the statues described above, however, it is the statue of David which is given the more important position in the painting. This different evaluation of the two representations within the picture would also appear to reflect contemporary events. In 1504, a commission of the most important artists, of which Botticelli was a member, had been convened to give advice with regard to where the statue of David, which had been sculpted by Michelangelo, should be put up. Botticelli decided initially in favour of its being placed in front of the Cathedral, and then for the Loggia dei Lanzi near the Palazzo Vecchio. The decision was finally left to Michelangelo himself, who selected the most conspicuous position for his sculpture, namely the location where Donatello's statue of Judith was currently standing; the latter was moved forthwith into the Loggia dei Lanzi.

Botticelli's creative powers faded rapidly towards the end of his life. If we are to believe his biographer, Giorgio Vasari, the painter was plagued in his final years by illness and infirmity. According to Vasari, he had become "so hunched that he had to walk with the aid of two sticks". Botticelli died in May, 1510, aged 65, and was buried in the graveyard near to Ognissanti; nowadays, buildings stand on the site.

The History of Lucretia, c. 1504
Botticelli was using the stories of Lucretia and Virginia (cf. Illus. p. 87) to refer to contemporary political events, namely the ousting of the Medici and the establishment of the Florentine republic

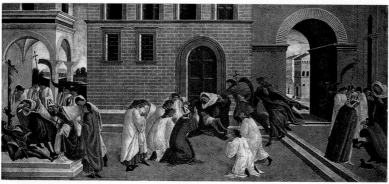

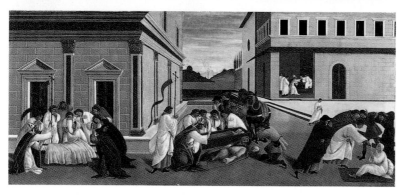

Scenes from the Life of San Zenobio,
c. 1500–05
San Zenobio was the first bishop of Florence.
Each scene should be read from left to right.
They appear as if lined up in a row. In the first
picture, we see Zenobio's refusal to marry, fol-
lowed by his baptism, the baptism of his
mother, and his appointment as bishop of
Florence. The next painting shows the mir-
acles performed by the bishop: he releases
two youths from the power of the Devil,
brings a dead child back to life, and restores
the sight of a blind man. The third panel like-
wise testifies to the miraculous abilities of the
bishop, as he brings the dead back to life in
all three episodes. The final picture depicts at
length the resurrection of a dead child and
also portrays the death of San Zenobio, who
died in 422.

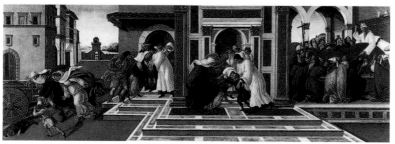

Scenes from the Life of San Zenobio (detail, cf. p. 90, third picture from top)
From the Christian point of view, the subject of death always includes the hope of resurrection. However, the promise of "eternal life" after death is unable to still the fantasies of a miraculous return to life here on earth, rendered visible in the belief in miracles expressed in such pictures.

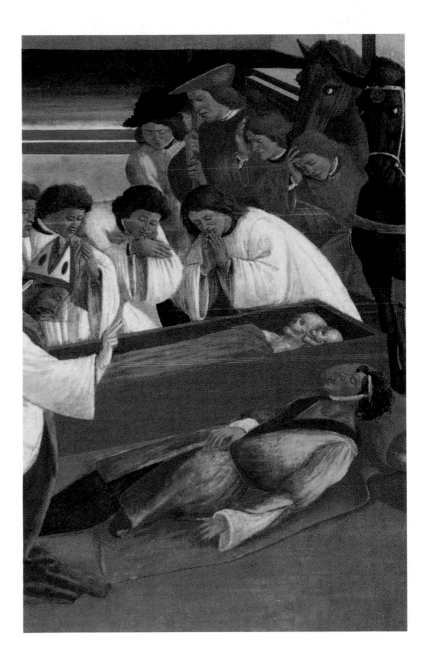

Sandro Botticelli 1444/45–1510: Life and work

1444/45 Alessandro di Mariano di Vanni Filipepi is born to the tanner Mariano di Vanni and his wife, Smeralda, in what is now Borgo Ognissanti No. 28 in Florence. Of the eight children born to his parents, only four brothers will become adults, Botticelli being the youngest.

1458 His father purchases a small country villa in Careggi, near Florence, and the family moves into a house in the Via della Vigna Nuova, which they rent from the powerful Rucellai family.

c. 1459/60 Botticelli turns to the art of the goldsmith.

1461/62 He changes his professional plans and commences an apprenticeship as a painter with Fra Filippo Lippi in Prato.

1464 Mariano, Botticelli's father, purchases a house in what is today the Via della Porcellana; here Botticelli will have his workshop from about 1470 until his death.

c. 1465 The young artist executes his first works under the supervision of Fra Filippo Lippi, his teacher.

1467 Botticelli's apprenticeship with Filippo Lippi ends in the course of this year. Lippi goes to Spoleto to decorate the chapel of the main chancel in the Cathedral with frescoes.

1470 Botticelli sets up a workshop of his own in his father's house in the Via della Porcellana. In June, the artist receives his first big commission, the virtue of *Fortitude*, from the Sei della Mercanzia in Florence. The selection of an artist who was still unknown at the time may have been influenced by the mediation of his neighbour Giorgio Antonio Vespucci.

1472 Botticelli registers in the guild list of the Compagnia degli Artisti di San Luca. In this year, Filippino Lippi, the son of Botticelli's teacher, Fra Filippo Lippi, appears in the lists as Botticelli's apprentice.

1473 On 20th January, the festival of St Sebastian, Botticelli's painting of the saint is erected in the Florentine church of Santa Maria Maggiore.

1474 Botticelli goes to Pisa, where he executes some frescoes in the Camposanto, the cemetery building. First, however, he is required to do a sample piece, an *Assumption of the Virgin*, now lost, in the Cathedral of Pisa. For reasons unknown to us, both this work and the frescoes in the Camposanto remain unfinished.

1475 Botticelli's connection over many years with the Medici family begins: he paints a standard – now lost – for a knightly tournament in honour of Giuliano de' Medici.

1477 Botticelli's fame spreads beyond the bounds of his home city: he paints a tondo of the Virgin for the Rome branch of the Florentine bank of Benedetto di Antonio Salutati.

1478 On 28th April, Giuliano de' Medici is murdered during mass in the Cathedral of Florence in the context of the conspiracy by the Pazzi family against the rule of the Medici; it is only with difficulty that Giuliano's elder brother, Lorenzo the Magnificent, can escape to the sacristy.

1480 Botticelli is commissioned by the Vespucci family to paint the fresco of *St Augustine* for the church of Ognissanti, situated in the immediate vicinity of his workshop; the fresco complements that of *St Jerome* by Domenico Ghirlandaio.

1481 Botticelli paints the Annunciation fresco for San Martino, a hospital for plague victims, between April and May. In July, the painter is summoned to Rome by Pope Sixtus IV to decorate the walls of the Sistine Chapel, the papal electoral chapel.

1482 Botticelli's father dies on 20th February. After finishing his work in Rome, the painter returns to Florence, where he contributes to the decoration of what is today the Sala dei Gigli in the Palazzo Vecchio. Nothing now remains of Botticelli's frescoes.

1483 Botticelli does four paintings on a story of courtly love from Boccaccio's "Decamerone" for the wedding of Giannozzo Pucci and Lucrezia Bini.

1485 The painter receives 78 florins and 15 soldi for an altarpiece commissioned by Giovanni Bardi.

1486 In connection with the wedding of Lorenzo Tornabuoni with Giovanna degli Albizzi, Botticelli decorates the walls of the Villa Lemmi, owned by the Tornabuoni, with frescoes.

1487 The Magistrato de' Massai della Camera commissions a tondo of the Virgin from Botticelli for their reception hall in the Palazzo Vecchio, a work identified by some researchers as the *Madonna della Melagrana*.

1489 Botticelli paints the *Annunciation* for the family chapel of Benedetto di Ser Francesco Guardi in the church of Cestello, today the Santa Maria Maddalena de' Pazzi.

1490 Together with Filippino Lippi, his former pupil, Perugino and Domenico Ghirlandaio, the painter executes frescoes in the country villa of Spedaletto for Lorenzo the Magnificent, which are destroyed in the 19th century by fire.

1491 Lorenzo the Magnificent consults Sandro Botticelli – together with other artists – concerning the competition for the decoration of the Cathedral's façade. The artist leaves uncompleted the execution of a mosaic in the vaulting of the Chapel of San Zenobio in the main chancel.

In July, Girolamo Savonarola becomes Prior of the Dominican monastery of San Marco. This marks the beginning of his growing influence on the increased religious awareness of the inhabitants of Florence.

1492 Lorenzo the Magnificent dies on 8th April.

1493 Botticelli's eldest brother, Giovanni, dies.

1494 His brother Simone returns from Naples; together, they purchase a country villa below the Bellosguardo with a view of the Arno valley. The Medici family is expelled from Florence. During the consultations that follow regarding the formation of a government, Girolamo Savonarola, the Dominican monk, gains more and more influence and power.

1495 Despite the expulsion of the Medici family, Sandro remains in contact with them: the wife of Lorenzo di Pierfrancesco de' Medici writes in a letter that she is expecting Botticelli, who is to execute some works of art in her country villa of del Trebbio.

1496 Botticelli is in contact with Michelangelo, who sends him a message for Lorenzo di Pierfrancesco, to be handed over when Botticelli is in the Villa del Trebbio again.

1497 The artist and a neighbour, the hosier Filippo di Domenico del Cavaliere, sign a contract agreeing not to annoy each other any more on pain of a fine of 50 florins.

On 7th February, Savonarola erects his first "bonfire of the vanities", on which the citizens of Florence should burn their luxury goods.

1498 On 23rd May, Girolamo Savonarola, accused of heresy, is hung and burnt at the stake on the Piazzo della Signoria. Botticelli appears deeply affected by Savonarola's death. On 15th November, Botticelli registers in the guild list of the Arte de' Medici e Speziali, the Guild of Doctors and Apothecaries, to which painters also belong.

1500 Botticelli paints the *Mystical Nativity*, the only painting dated and signed by the artist.

1502 The artist is secretly accused of having homo-erotic relations with his pupils, an accusation that is not followed up.

1504 Botticelli participates in the committee convened to decide upon the location of the statue of David by Michelangelo.

1510 On 17th May, Sandro Botticelli dies at the age of 65/66, and is buried in the cemetery of Ognissanti, on which buildings now stand.

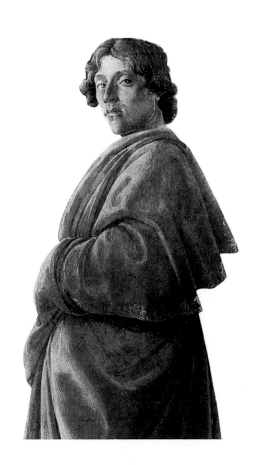

List of Plates

45 bottom
Detail from illustration p. 44

47
Detail from illustration p. 45, top

48 top
The First Episodes in the Story of Nastagio degli
Onesti, 1483
Tempera on panel, 83 x 138cm
Derechos reservados © Museo del Prado, Madrid

48 bottom
Further Episodes in the Story of Nastagio degli
Onesti, 1483
Tempera on panel, 82 x 138cm
Derechos reservados © Museo del Prado, Madrid

49 top
Further Episodes in the Story of Nastagio degli
Onesti, 1483
Tempera on panel, 84 x 142cm
Derechos reservados © Museo del Prado, Madrid

49 bottom
The Marriage Feast of Nastagio degli Onesti, 1483
Tempera on panel, 84 x 142cm
Private collection

50
Detail from illustration p. 51

51
The Birth of Venus, c. 1485
Tempera on canvas, 172.5 x 278.5cm
Florence, Galleria degli Uffizi

52
Detail from illustration p. 51

53
Detail from illustration p. 51

54
Giovanna degli Albizzi Receiving a Gift of Flowers
from Venus, 1486
Fresco, detached and mounted on canvas,
211 x 284cm
Paris, Musée du Louvre

55
Lorenzo Tornabuoni Presented by Grammar to Prudentia
and the other Liberal Arts, 1486
Fresco, detached and mounted on canvas,
238 x 284cm
Paris, Musée du Louvre

56
The Virgin and Child with Six Angels (The Madonna
della Melagrana), c. 1485
Tempera on panel, diameter 143.5cm
Florence, Galleria degli Uffizi

57
Detail from illustration p. 61

58
Adoration of the Magi, c. 1481/82
Tempera on panel, 70 x 103cm
© 1992 National Gallery of Art, Washington (DC),
Andrew W. Mellon Collection

59
Detail from illustration p. 56

60 top
Three Angels, c. 1475–80
Pen with brown shading, pink wash and white
heightening on pink prepared paper,
10 x 23.5cm
Florence, Galleria degli Uffizi, Gabinetto dei Disegni

60 bottom left
Angel, c. 1485–90
Chalk and pen, washed and heightened with white,
26.6 x 16.5cm
Florence, Galleria degli Uffizi, Gabinetto dei Disegni

60 bottom right
St John the Baptist, c. 1485
Pen, with bistre shadows and white heightening on
prepared pink paper, 36 x 15.1cm
Florence, Galleria degli Uffizi, Gabinetto dei Disegni

61
Allegory of Abundance (Abundantia), c. 1480
Pen and brown ink and faint brown wash over black
chalk on paper tinted pink, heightened with white,
31.7 x 25.3cm
London, The British Museum, Department of Prints and
Drawings

62
Detail from illustration p. 63, top

63 top
The Virgin and Child Attended by Four Angels and by
Six Saints (The San Barnaba Altarpiece), c. 1487
Tempera on panel, 268 x 280cm
Florence, Galleria degli Uffizi

63 bottom
The Virgin and Child Enthroned between St John the Baptist
and St John the Evangelist (The Bardi Altarpiece), 1484
Tempera on poplar, 185 x 180cm
Berlin, Staatliche Museen zu Berlin – Preußischer
Kulturbesitz, Gemäldegalerie

64
The Annunciation, c. 1489/90
Tempera on panel, 150 x 156cm
Florence, Galleria degli Uffizi

65 top
Detail from illustration p. 64

65 bottom
Detail from illustration p. 64

66
The Coronation of the Virgin with Four Saints: St John the
Evangelist, St Augustine, St Jerome and St Eligius (The
San Marco Altarpiece), c. 1490
Tempera on panel, 378 x 258cm
Florence, Galleria degli Uffizi

67
The Virgin and Child with the Young St John the Baptist,
c. 1493
Tempera on panel, 47.7 x 38.1cm
Tokyo, Ishizuka Collection

68 top
The Virgin and Child with Three Angels (The Madonna
del Padiglione or Ambrosiana Tondo), c. 1493
Tempera on panel, diameter 65cm
Milan, Pinacoteca Ambrosiana

68 bottom
The Virgin Adoring the Child, c. 1490
Tempera on panel, diameter 59.6cm
© 1992 National Gallery of Art, Washington (DC),
Samuel H. Kress Collection

69
The Virgin and Child with Two Angels, c. 1493
Oil and tempera on panel, diameter 34cm
Chicago (IL), The Art Institute of Chicago,
Max and Leola Epstein Collection

70
Lamentation over the Dead Christ, c. 1495
Tempera on panel, 107 x 71cm
Milan, Museo Poldi Pezzoli

71
Lamentation over the Dead Christ with St Jerome,
St Paul and St Peter, c. 1490
Tempera on poplar, 140 x 207cm
Munich, Alte Pinakothek

72
The Calumny of Apelles, c. 1495
Tempera on panel, 62 x 91cm
Florence, Galleria degli Uffizi

73
Detail from illustration p. 72

74
St Augustine Writing in his Cell, c. 1490–94
Tempera on panel, 41 x 27cm
Florence, Galleria degli Uffizi

75 top left
Portrait of a Man (Michele Marullo Tarcagniota?),
c. 1490–95
Canvas, transferred from panel, 49 x 35cm
Barcelona, Col.leció Cambó, Sra. Helena Cambó de
Guardans

75 top right
Portrait of Lorenzo di Ser Piero Lorenzi, c. 1495–1500
Tempera on panel, 50 x 36.5cm
Philadelphia (PA), Philadelphia Museum of Art:
The John G. Johnson Collection

75 bottom left
Portrait of a Young Man, c. 1485–90
Tempera on panel, 37.5 x 28.2cm
London, The National Gallery, reproduced by
courtesy of the Trustees

75 bottom right
Portrait of a Young Man, c. 1489/90
Tempera on panel, 41 x 31cm
© 1992 National Gallery of Art, Washington (DC),
Andrew W. Mellon Collection

76 top
Inferno, Canto XVIII, 1480–90
Illustration for Dante's "Divine Comedy"
Silverpoint on parchment, subsequently completed in pen
and ink, coloured with tempera, c. 32 x 47cm
Berlin, Staatliche Museen zu Berlin – Preußischer
Kulturbesitz, Kupferstichkabinett

76 center
Detail from: Inferno, Canto XXXI, The Giants,
1480–90
Illustration for Dante's "Divine Comedy"
Silverpoint on parchment, subsequently completed
in pen and ink, c. 32 x 47cm
Berlin, Staatliche Museen zu Berlin – Preußischer
Kulturbesitz, Kupferstichkabinett

76 bottom
Detail from: Inferno, Canto XXXIV, Lucifer, 1480–90
Illustration for Dante's "Divine Comedy"
Silverpoint on parchment, subsequently completed
in pen and ink
Berlin, Staatliche Museen zu Berlin – Preußischer
Kulturbesitz, Kupferstichkabinett

77 top left
Paradise, Canto VI, 1495–1500
Illustration for Dante's "Divine Comedy"
Silverpoint on parchment, subsequently completed
in pen and ink, c. 32 x 47cm
Berlin, Staatliche Museen zu Berlin – Preußischer
Kulturbesitz, Kupferstichkabinett

77 top right
Portrait of Dante, c. 1495
Tempera on panel, 54.7 x 47.5cm
Geneva, private collection

77 left
Detail from illustration p. 76, top

78
The Mystical Nativity, c. 1500
Tempera on canvas, 108.5 x 75cm
London, The National Gallery, reproduced by
courtesy of the Trustees

79
Detail from illustration p. 78

80
The Crucifixion with the Penitent Magdalene and
an Angel (Mystical Crucifixion), c. 1500
Tempera and oil on canvas, 72.3 x 51.3cm

Cambridge (MA), courtesy of the Fogg Art Museum, Harvard University Art Museums, The Friends of the Fogg Museum of Art Fund

81
The Agony in the Garden (Christ on the Mount of Olives), c. 1500
Tempera on panel, 53 x 35 cm
Granada, Museo de la Capilla Real

82
The Transfiguration, St Jerome, St Augustine, c. 1500
Tempera on panel, 27.2 x 35.3 cm
Rome, Galleria Pallavicini

83 top
Detail from illustration p. 83, bottom

83 bottom
The Last Communion of St Jerome, c. 1495
Tempera on panel, 34.3 x 25.4 cm
© 1981 The Metropolitan Museum of Art, New York (NY), Bequest of Benjamin Altman, 1913. (14. 40. 642)

84
Anonymous:
The Execution of Savonarola on the Piazza della Signoria, 1498
Tempera on panel
Florence, Museo di San Marco

85
Fra Bartolommeo:
Girolamo Savonarola (1452–1498), c. 1497
Oil on panel, 53 x 47 cm
Florence, Museo di San Marco

86
Judith Leaving the Tent of Holofernes, c. 1495–1500
Tempera on panel, 36.5 x 20 cm
Amsterdam, Rijksmuseum

87 top
The History of Virginia, c. 1504
Tempera and oil on panel, 85 x 165 cm
Boston (MA), Isabella Stewart Gardner Museum

87 bottom
Detail from illustration p. 87, top

88
Detail from illustration p. 89

89
The History of Lucretia, c. 1504
Tempera and oil on panel, 83.5 x 180 cm
Boston (MA), Isabella Stewart Gardner Museum

90 top to bottom
The Early Life of San Zenobio and his Appointment as Bishop, c. 1500–05
Tempera on panel, 66.5 x 149.5 cm
London, The National Gallery, reproduced by courtesy of the Trustees

Three Miracles of San Zenobio, c. 1500–05
Tempera on panel, 65 x 139.5 cm
London, The National Gallery, reproduced by courtesy of the Trustees

Three Miracles of San Zenobio, c. 1500–05
Tempera on panel, 67.3 x 150.5 cm
© 1989 The Metropolitan Museum of Art, New York (NY), John Stewart Kennedy Fund, 1911. (11. 98)

The Ninth Miracle and the Death of San Zenobio, c. 1500–05
Tempera on panel, 66 x 182 cm
Dresden, Staatliche Kunstsammlungen, Gemäldegalerie Alte Meister

91
Detail from illustration p. 90, third picture from top

The Publishers would like to thank those museums, galleries, collectors and photographers who have supported them in producing this work. In addition to those persons and institutions cited in the legends to the pictures, the following should also be mentioned:
Jörg P. Anders (15, 63 bottom, 76)
Raffaelo Bencini, Florence (6, 8 top, 9, 13 top right, 13 bottom right, 16, 20, 24 bottom, 25, 26, 27, 30, 31, 34, 35, 36, 40, 44, 56, 60, 63 top, 66, 68 top, 70, 72, 74, 81, 82)
Joachim Blauel, Artothek (71)
Richard Carafelli (75 bottom right)
Greg Heins (21, 89)
Rosa Mai (77)
© Photo R.M.N., Paris (54, 55)
Sächsische Landesbibliothek, Dresden/Deutsche Fotothek (90 bottom)
Scala, Antella (13 top left, 17, 18 right, 22, 51, 64, 84, 85, 87)

Professor Helen Christensen is the Director of the Centre
f
U
c
oth
disease, and
She has over 300 research publications, chapters,
websites and is listed in the top 1 per cent in the field of
psychiatry/psychology internationally.

Professor Kathleen Griffiths is Deputy Director of the
Centre for Mental Health Research at The Australian
National University and Director of the Depression and
Anxiety Consumer Research Unit. Her research focuses on
the use of the Internet as a self-help tool for improving
mental health, developing programmes for reducing the
stigma associated with depression and understanding the
perspectives, information needs and mental health research
priorities of consumers. She has 150 research publications,
books, chapters and websites.

www.moodgym.anu.edu.au